Dogs

500 Pooch Portraits to Brighten Your Day

Michelle Perkins

AMHERST MEDIA, INC. ■ BUFFALO, NY

This book is dedicated to animal lovers everywhere—but especially to pet rescue volunteers and veterinary care providers. Thank you for making the world a happier, healthier place for our animal companions!

Copyright © 2018 by Michelle Perkins
All rights reserved.
All photographs used under Creative Commons CC0.

Published by:
Amherst Media, Inc., P.O. Box 538, Buffalo, N.Y. 14213
www.AmherstMedia.com

Publisher: Craig Alesse
Senior Editor/Production Manager: Michelle Perkins
Editors: Barbara A. Lynch-Johnt, Beth Alesse
Acquisitions Editor: Harvey Goldstein
Associate Publisher: Katie Kiss
Editorial Assistance from: Roy Bakos, Carey A. Miller, Rebecca Rudell, Jen Sexton
Business Manager: Sarah Loder
Marketing Associate: Tonya Flickinger

ISBN-13: 978-1-68203-332-6
Library of Congress Control Number: 2017963168
Printed in The United States of America.
10 9 8 7 6 5 4 3 2 1

www.facebook.com/AmherstMediaInc
www.youtube.com/AmherstMedia
www.twitter.com/AmherstMedia

AUTHOR A BOOK WITH AMHERST MEDIA!

Are you an accomplished photographer with devoted fans? Consider authoring a book with us and share your quality images and wisdom with your fans. It's a great way to build your business and brand through a high-quality, full-color printed book sold worldwide. Our experienced team makes it easy and rewarding for each book sold—no cost to you. E-mail submissions@amherstmedia.com *today!*

Introduction

Ask any dog lover: dogs and puppies are the best thing ever! Dogs lift our moods, lower our blood pressure, and improve our sense of well-being. In fact, people who have pets in their lives even live longer! In this book, we've collected five hundred photos that capture the beauty and personality of a wide range of breeds—and a wide variety of dogs' favorite activities, from lazy naps to spirited romps on the beach. Inspirational quotes about dogs and their honored roles in our families add another level of optimism and love. For animal lovers of all ages, just a few minutes with these adorable canine faces provides a boost that will last all day!

Contents

Introduction . 3

1. Wet and Wild. 4
2. Friends and Family. 16
3. Outdoor Adventures 28
4. My Favorite Things 66
5. Sweet and Silly Faces 69
6. Action! . 100
7. Time to Relax 107

Conclusion . 127

1. Wet and Wild

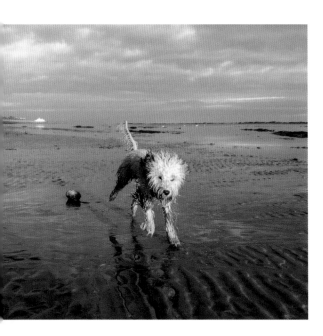

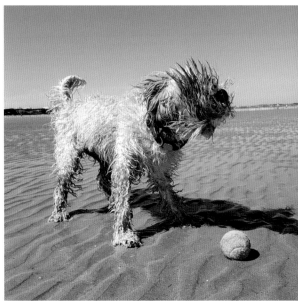

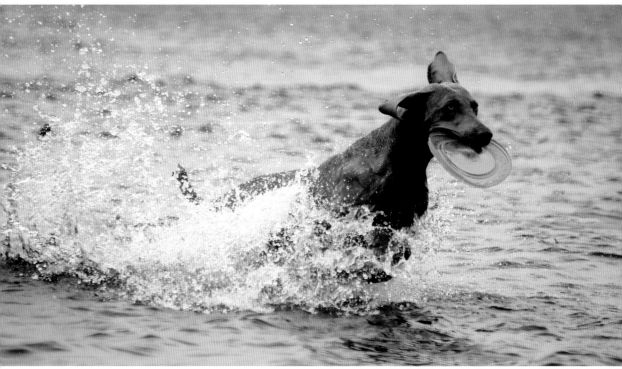

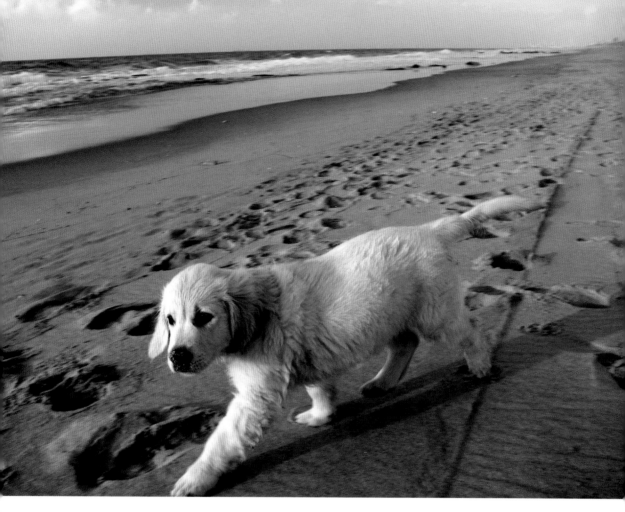

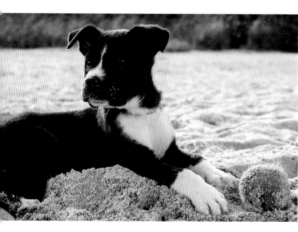

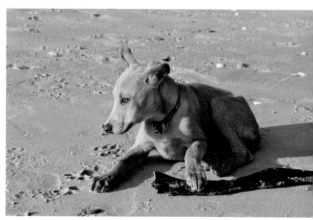

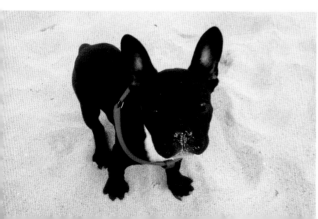

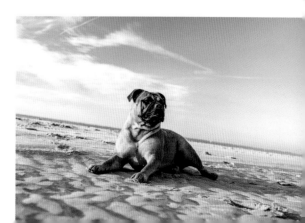

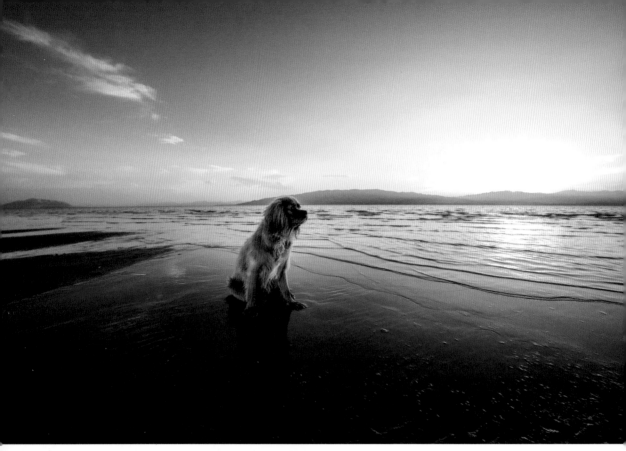

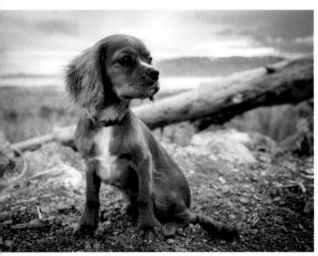

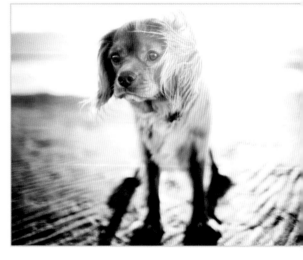

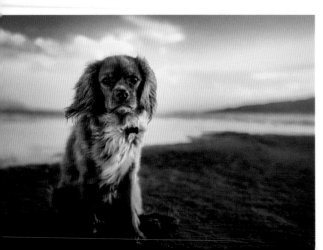

"A dog can't think that much about what he's doing, he just does what feels right."

–Barbara Kingsolver, author

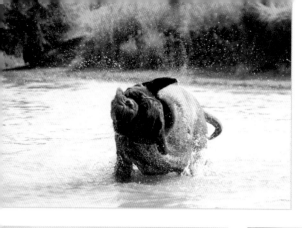
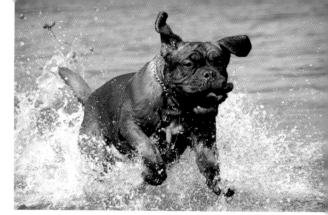
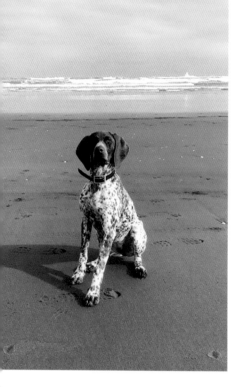
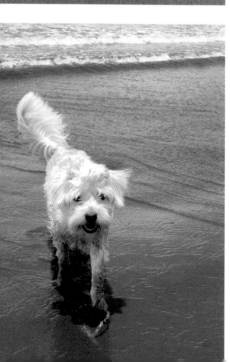
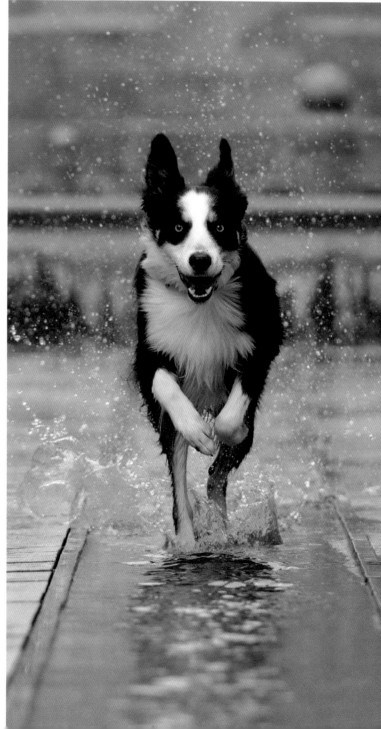

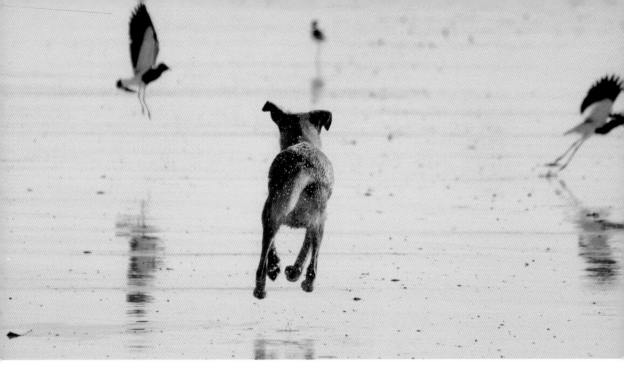

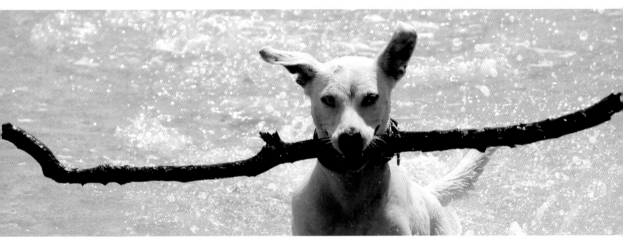

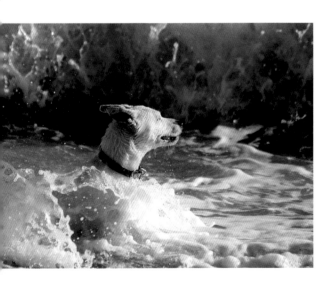

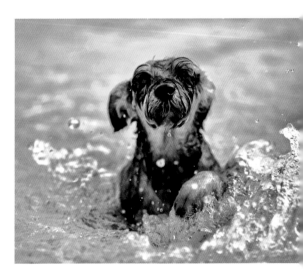

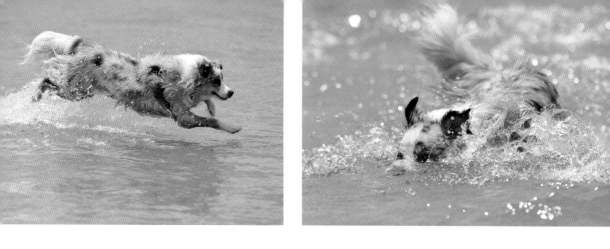

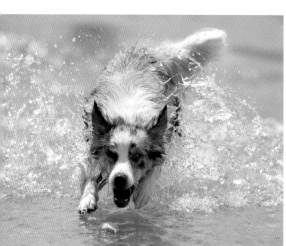

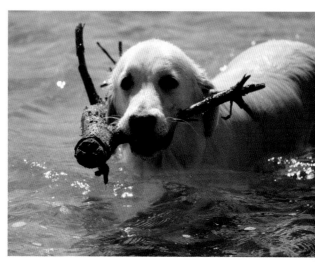

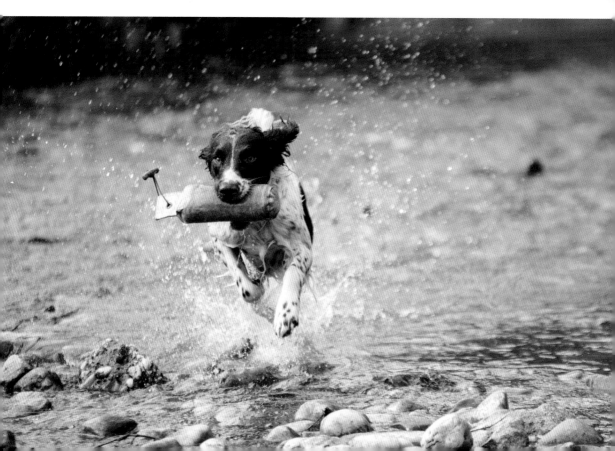

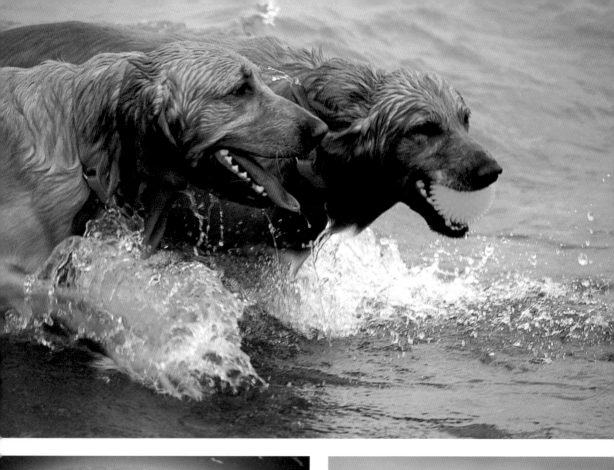

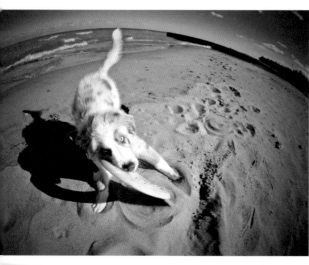

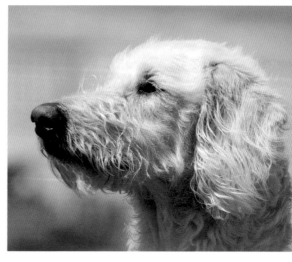

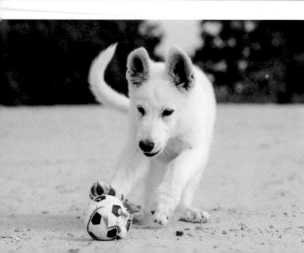

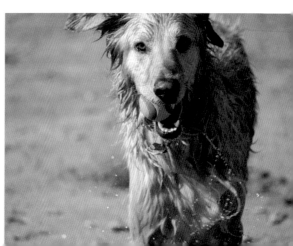

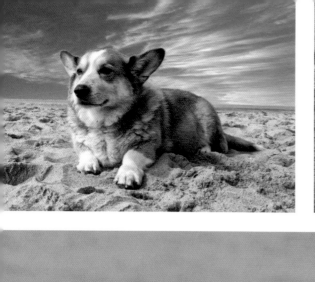
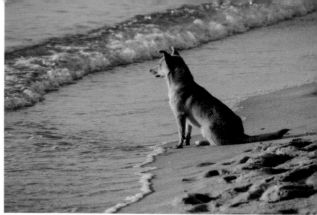
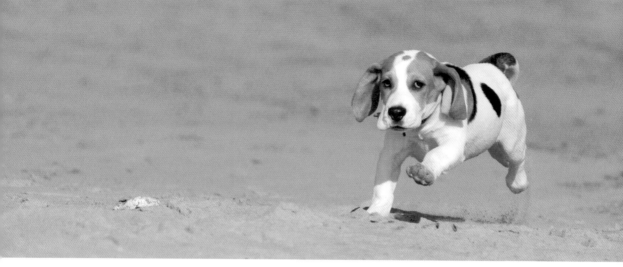

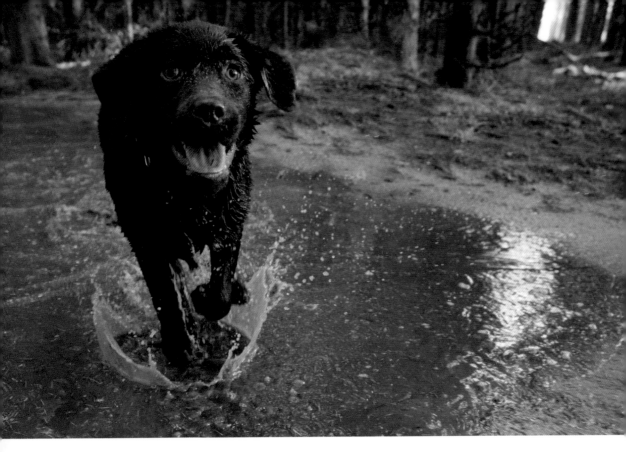

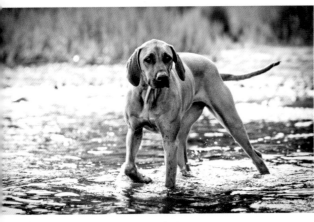

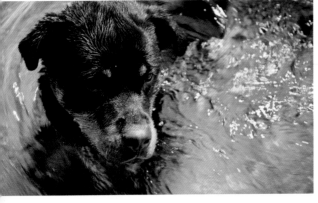

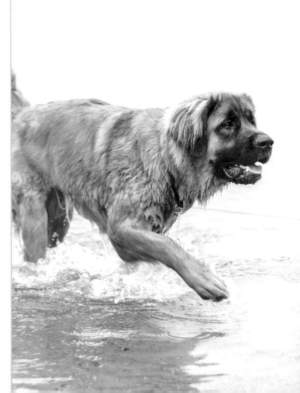

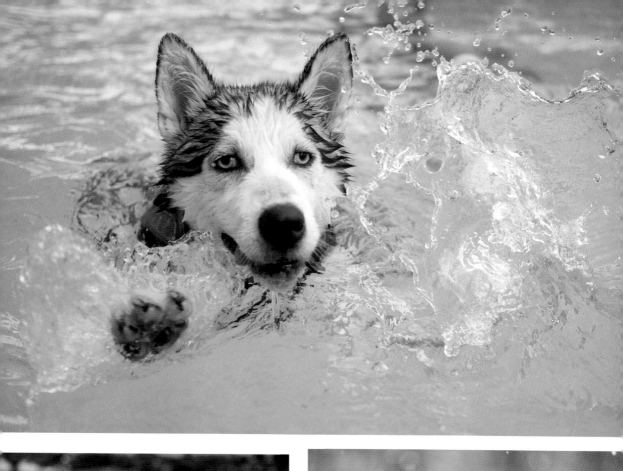

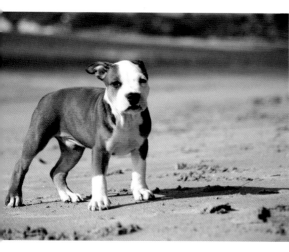

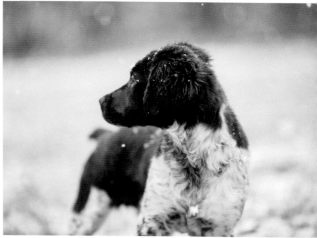

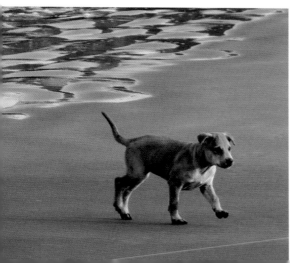

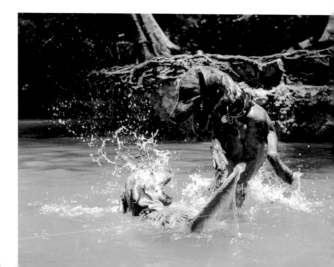

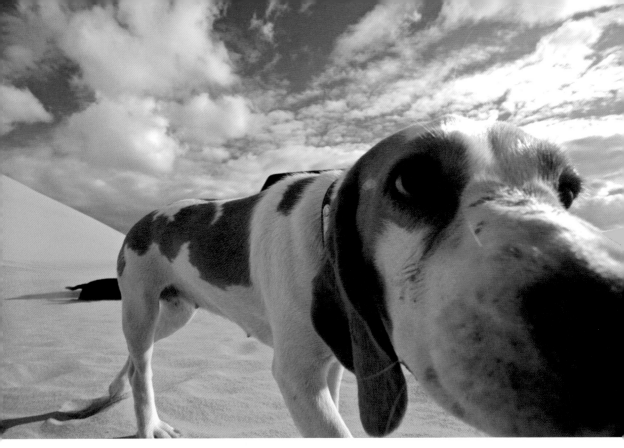

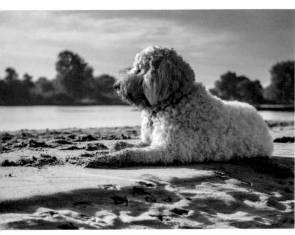

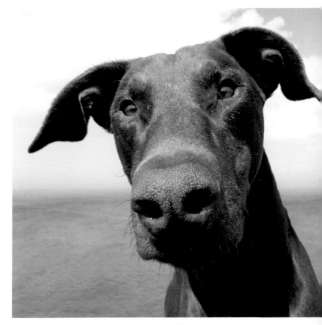

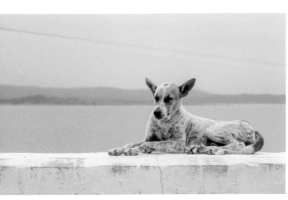

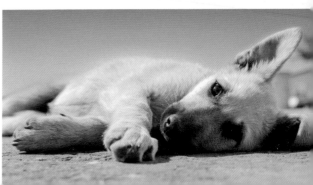

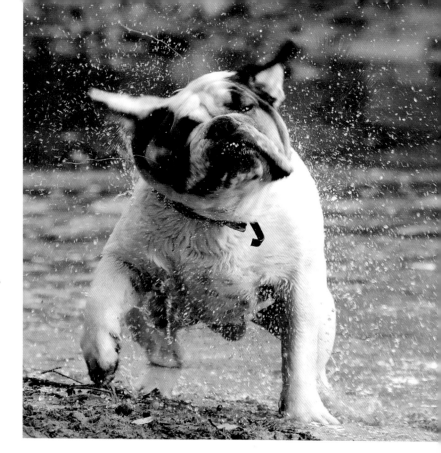

"I think dogs are the most amazing creatures; they give unconditional love. For me, they are the role model for being alive."

—Gilda Radner, comedian

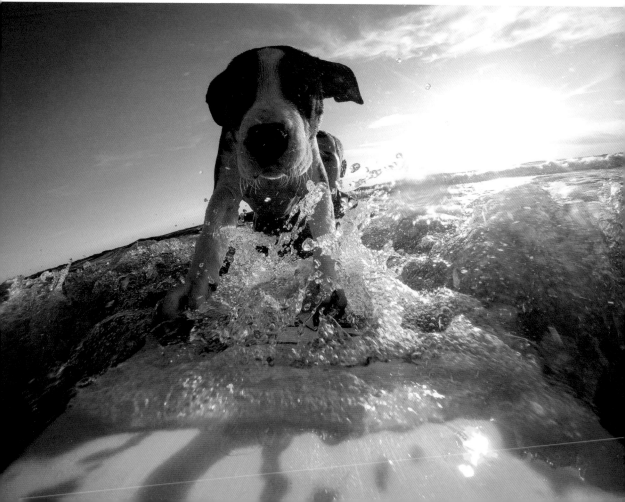

2. Friends and Family

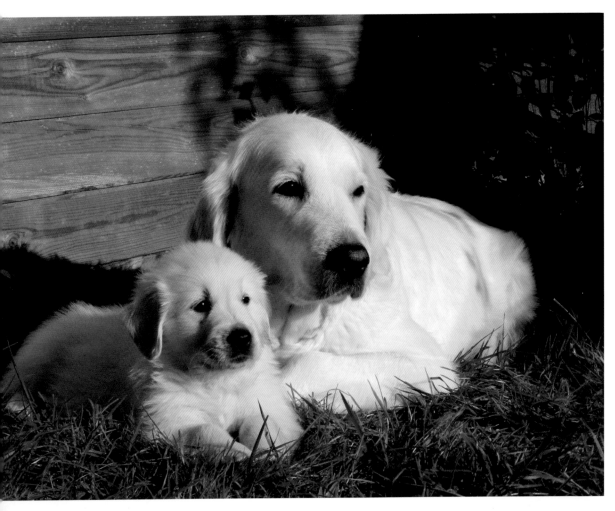

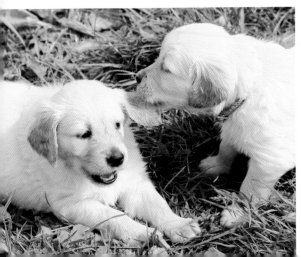

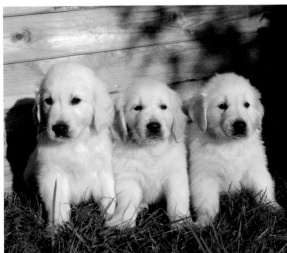

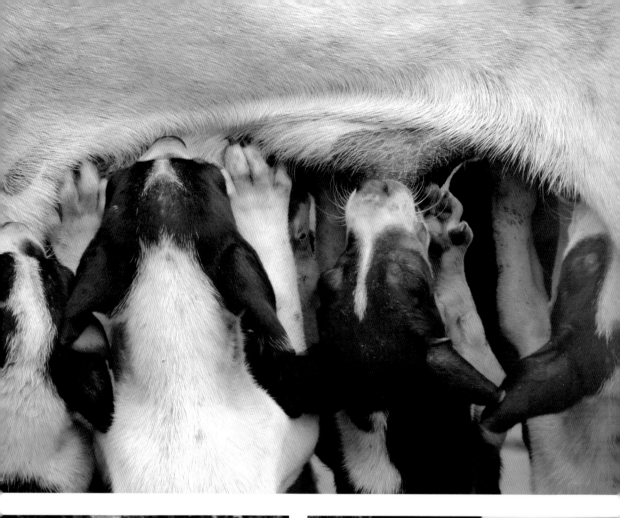

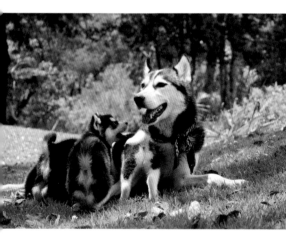

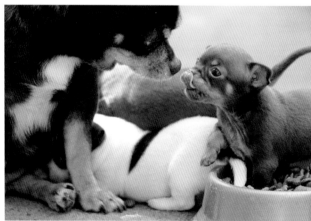

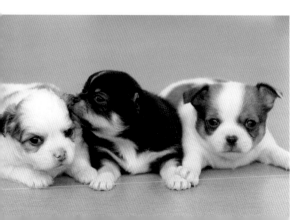

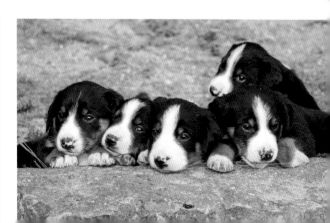

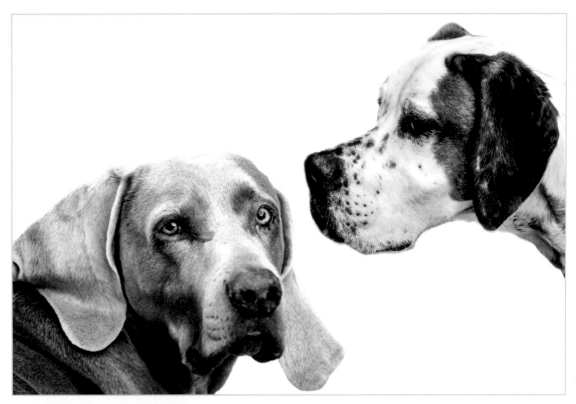

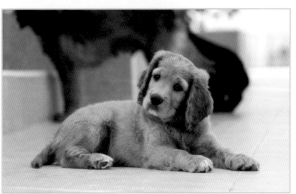

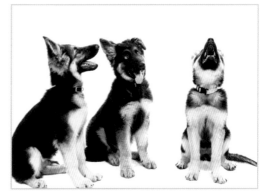

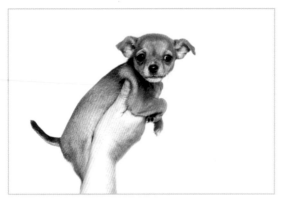

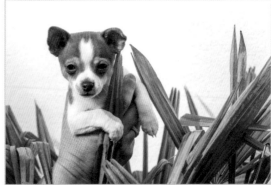

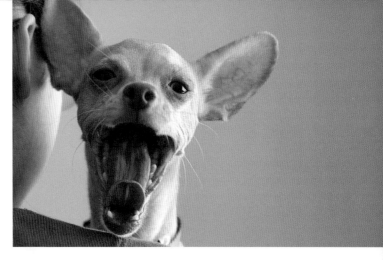

"Dogs are better than human beings because they know but do not tell."

—Emily Dickinson, poet

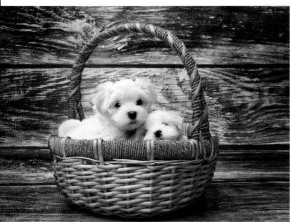

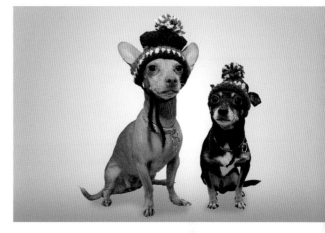

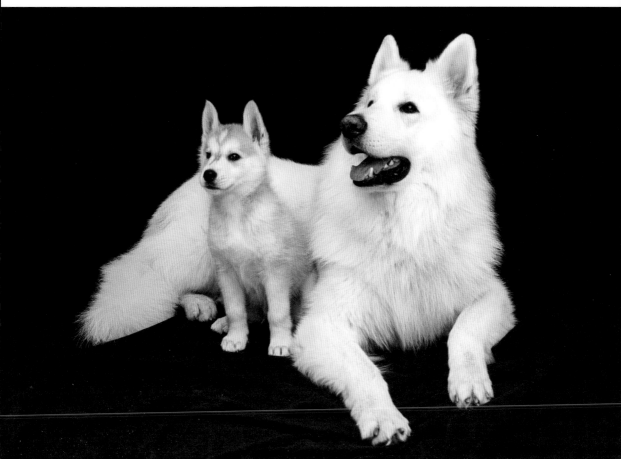

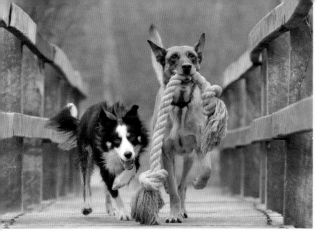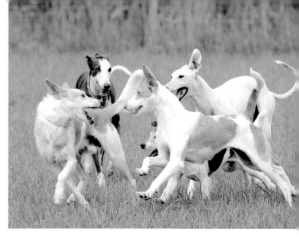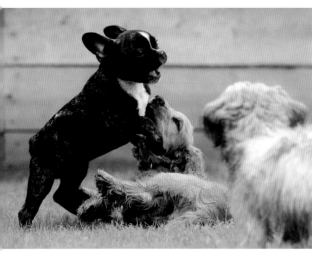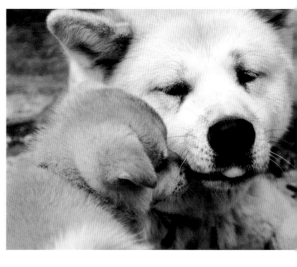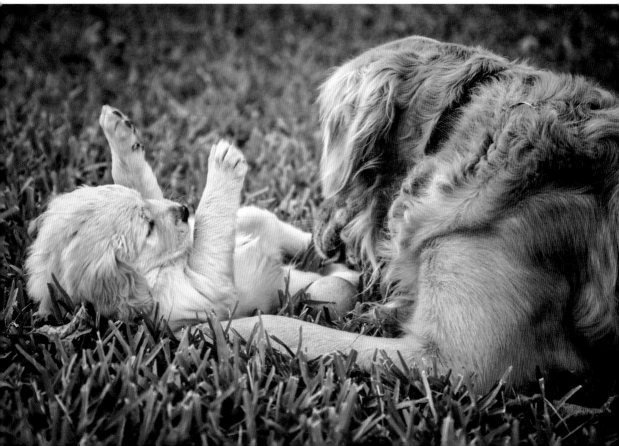

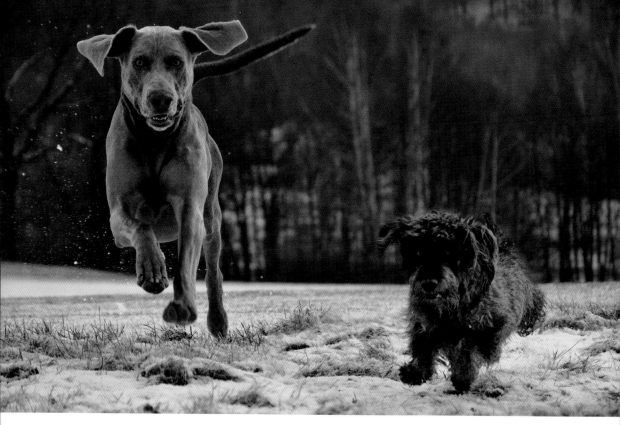

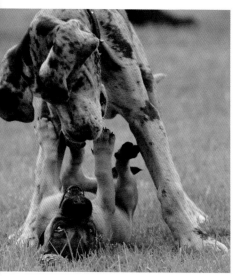

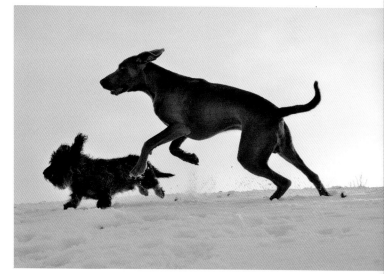

"Why does watching a dog be a dog fill one with happiness?"

—Jonathan Safran Foer, author

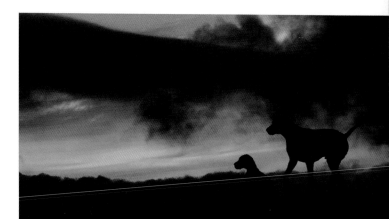

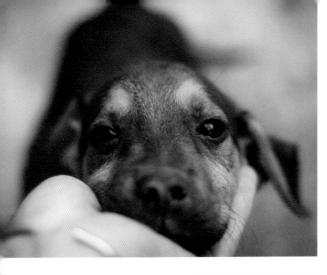
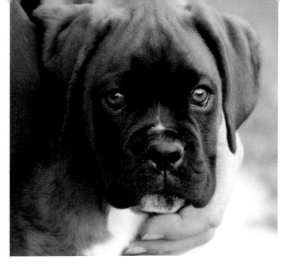
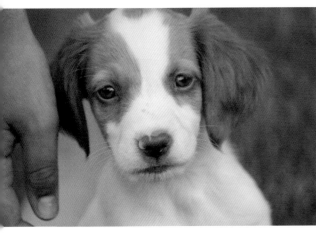
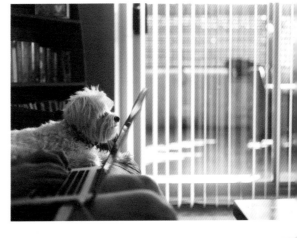
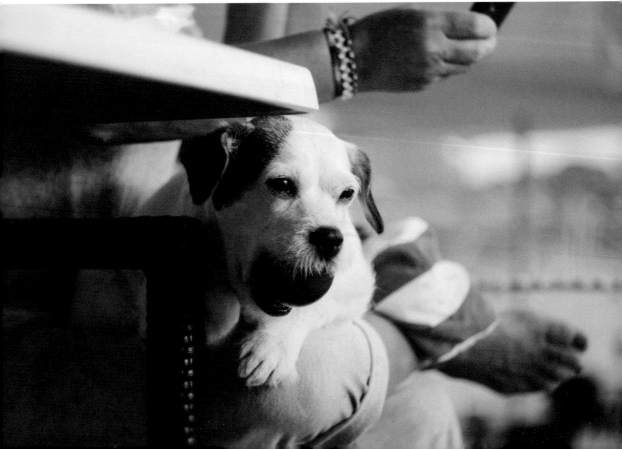

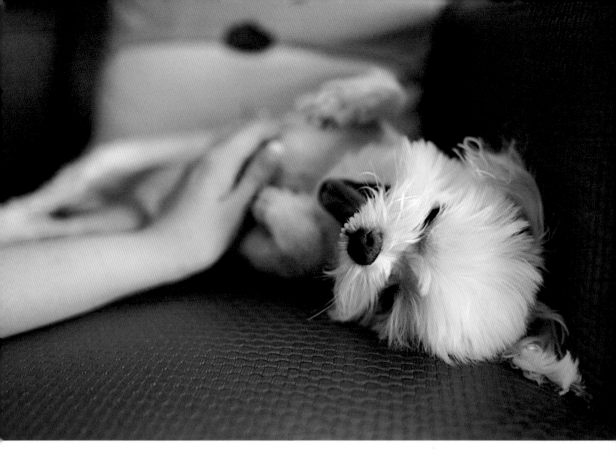

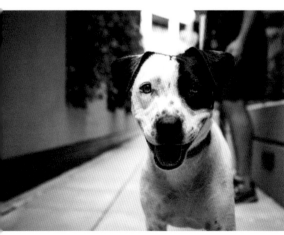

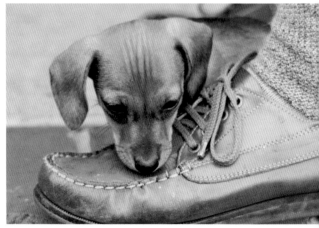

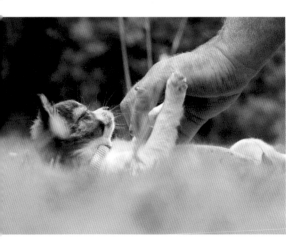

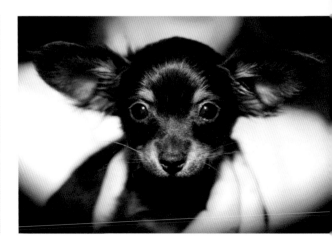

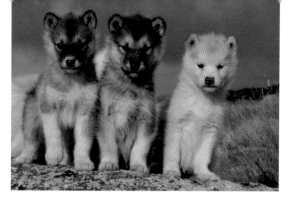
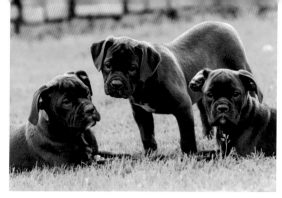
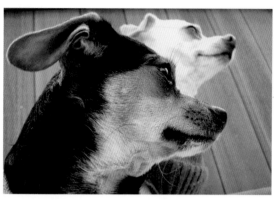
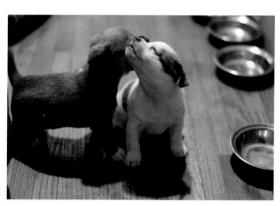
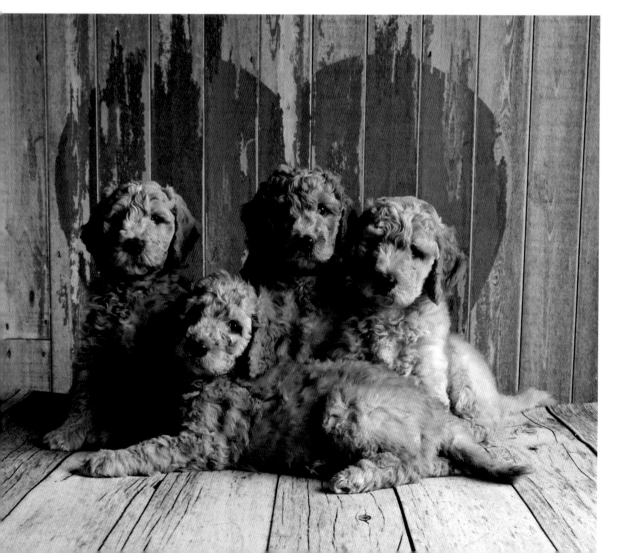

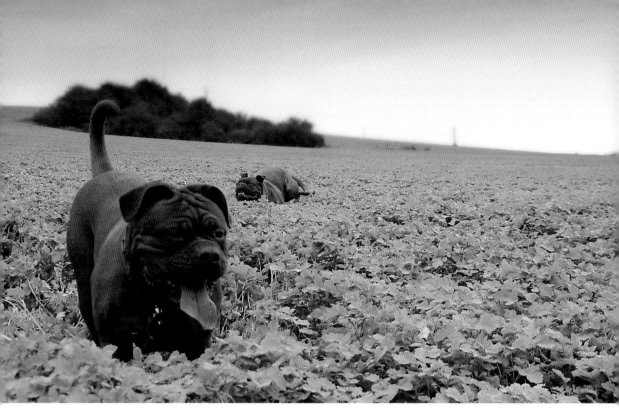

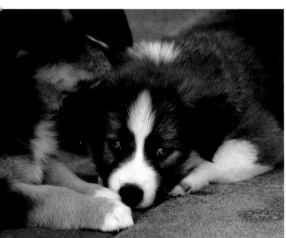

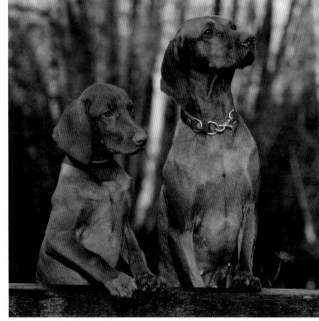

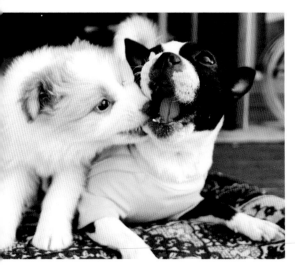

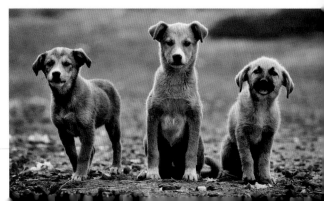

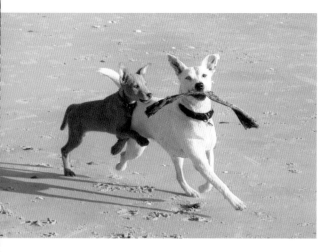
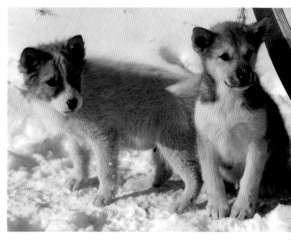
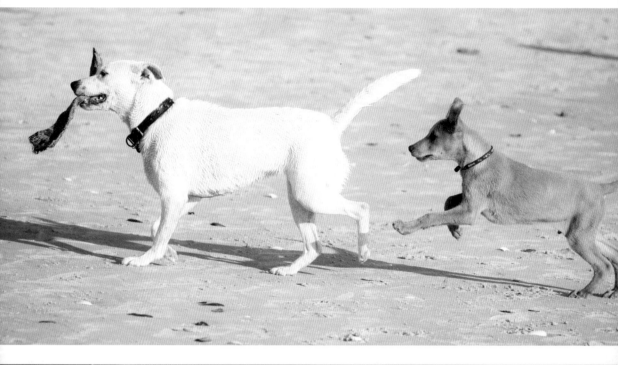
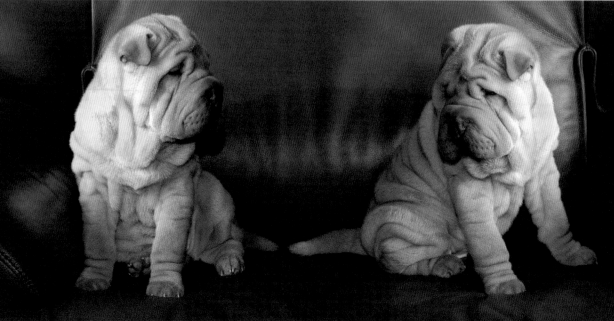

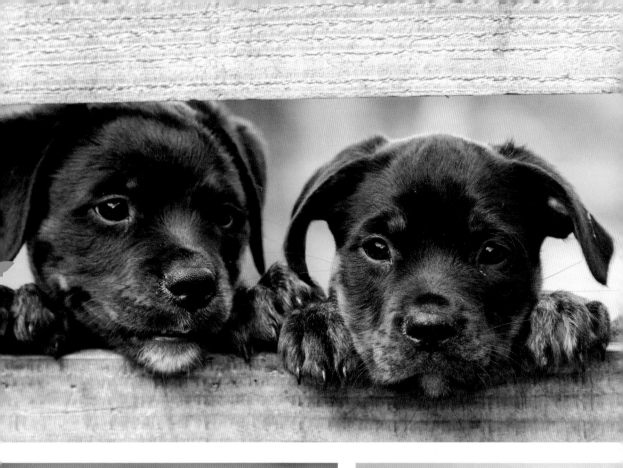

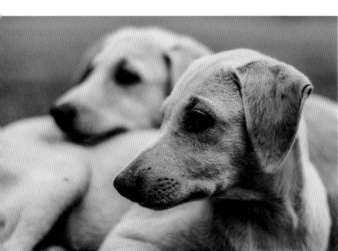

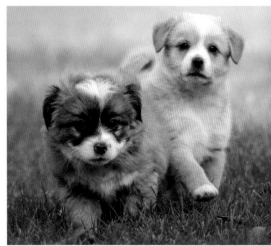

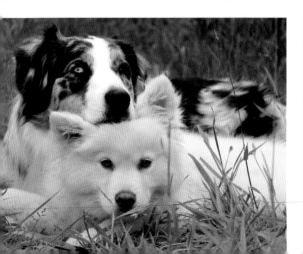

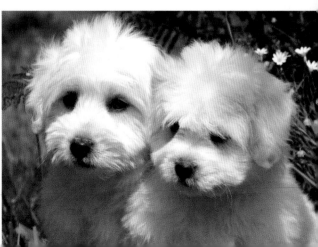

3. Outdoor Adventures

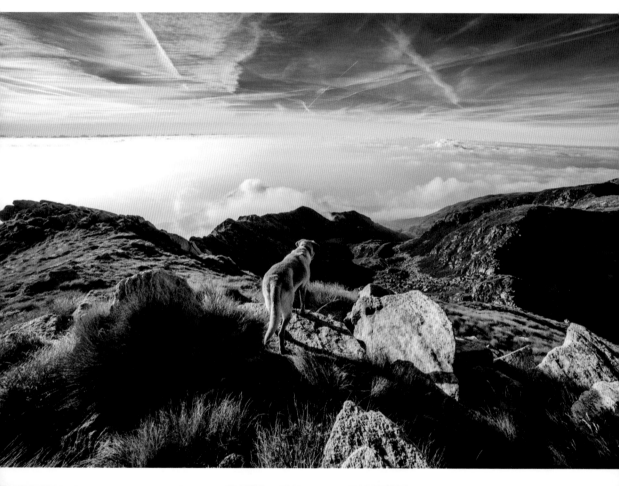

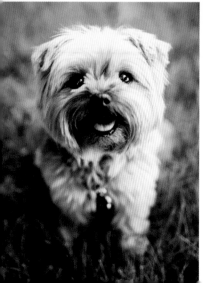

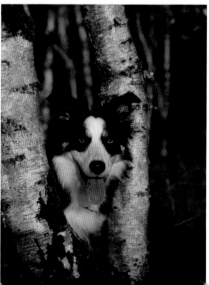

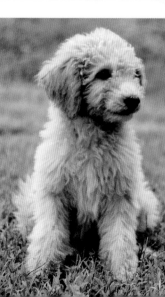

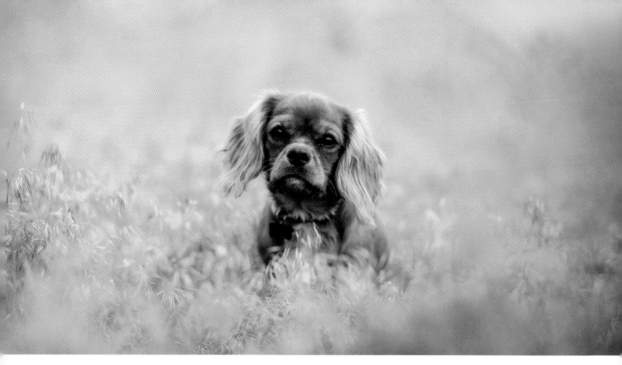

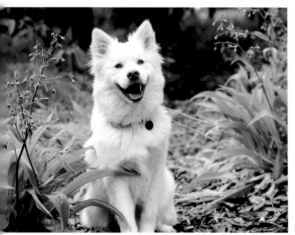

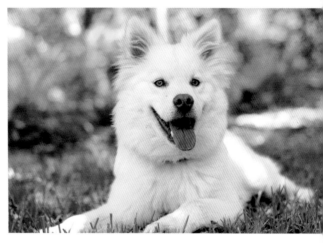

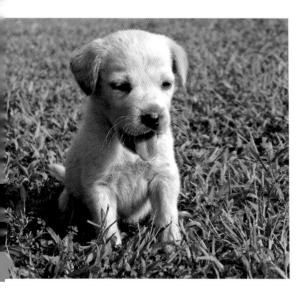

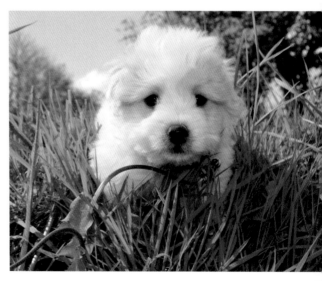

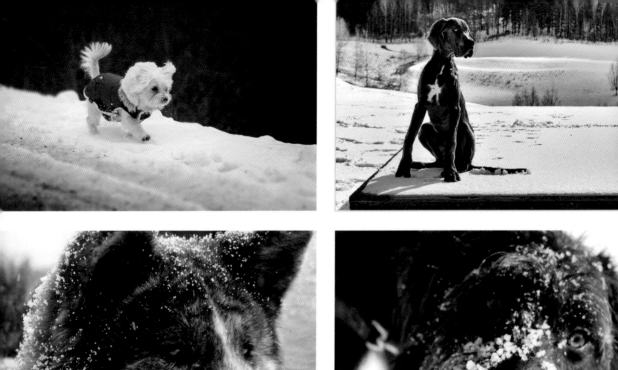

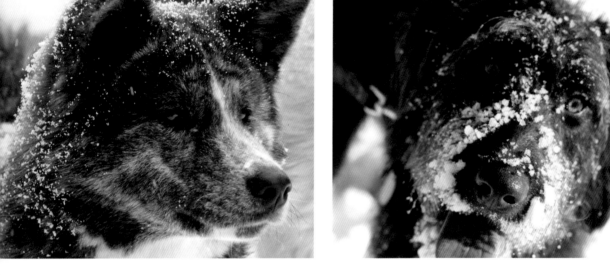

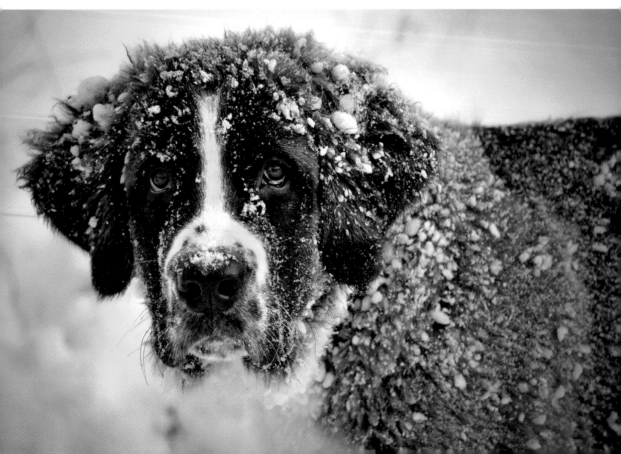

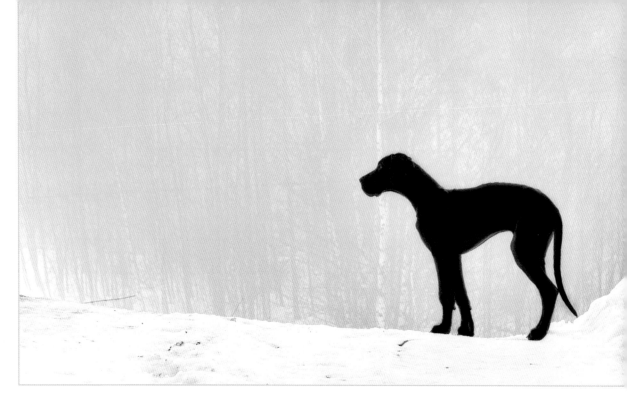

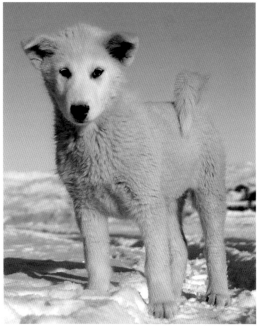

"Dogs are not our whole life, but they make our lives whole."

—Roger Caras, photographer and writer

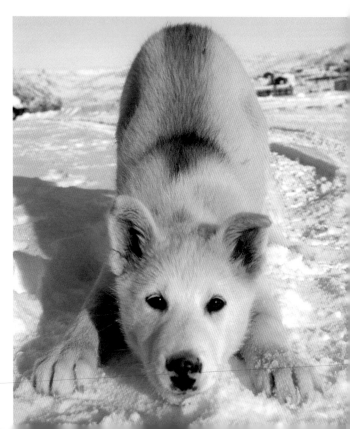

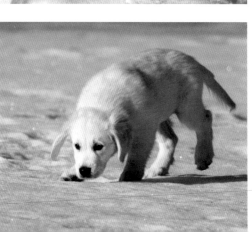

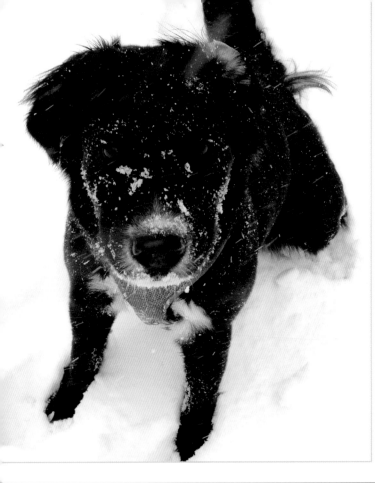
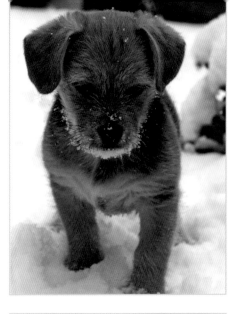

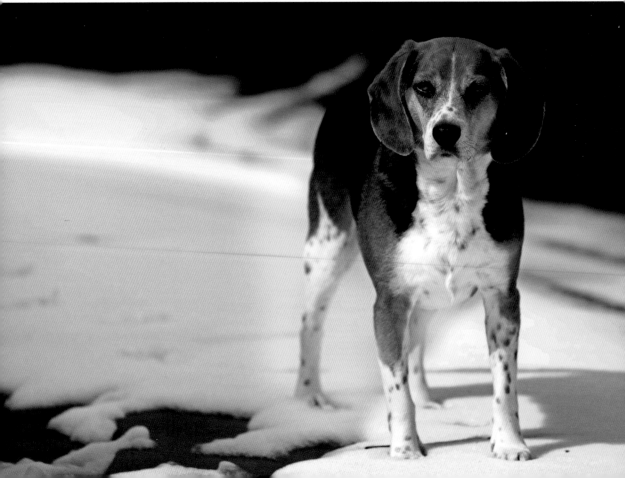

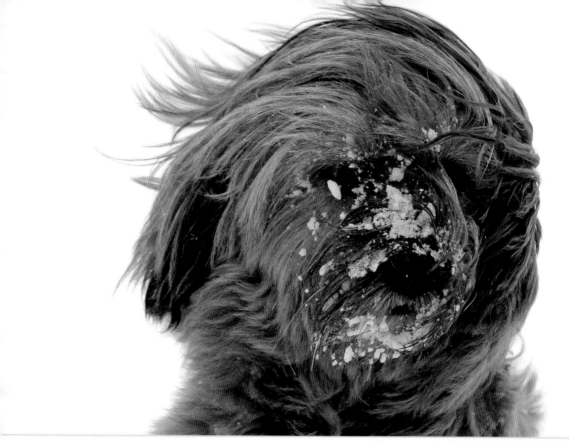

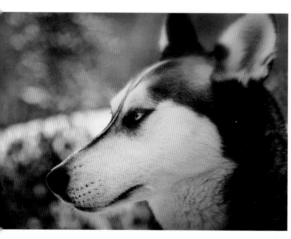

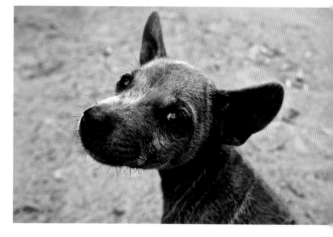

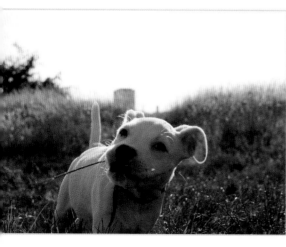

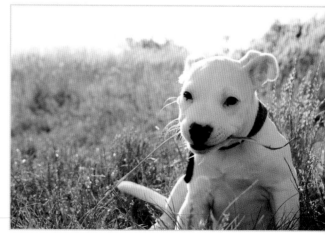

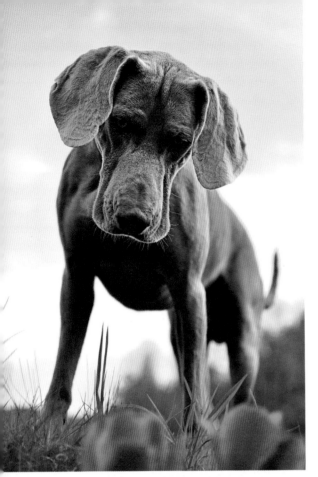
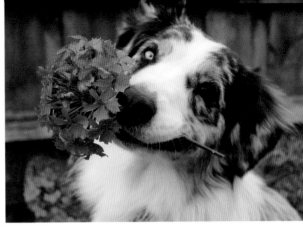
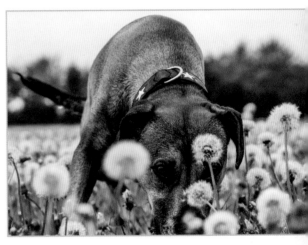
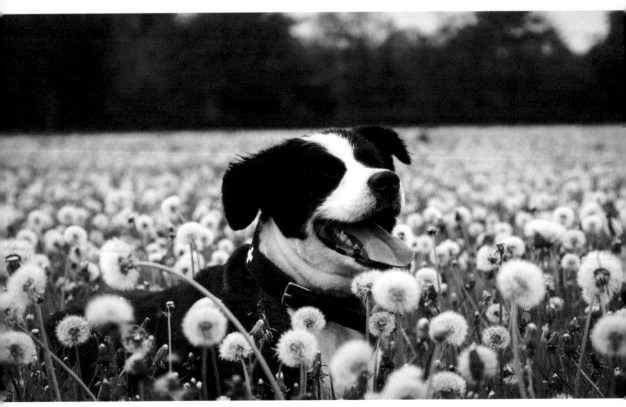

"No one appreciates the very special genius of your conversation as the dog does."

–Christopher Morley, author

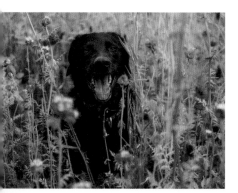

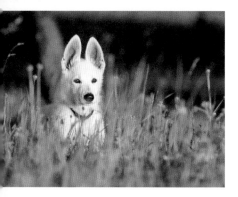

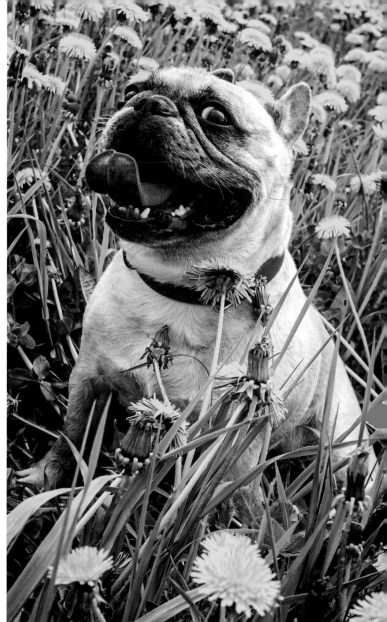

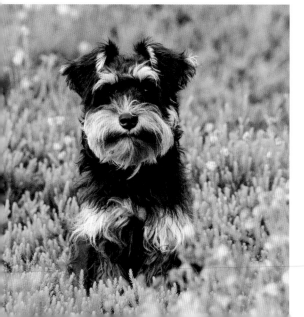

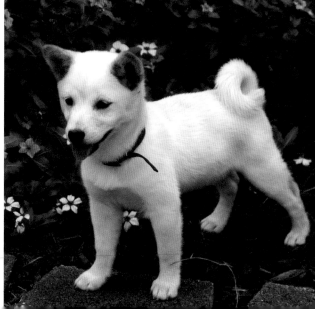

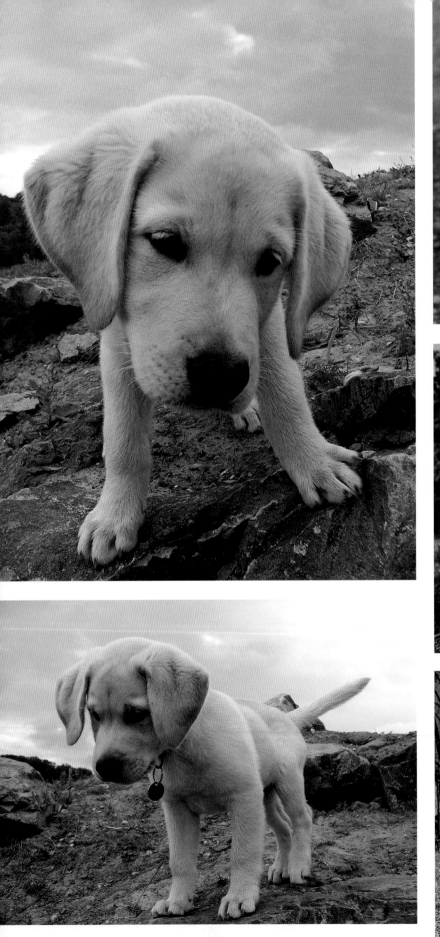
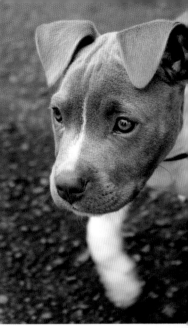
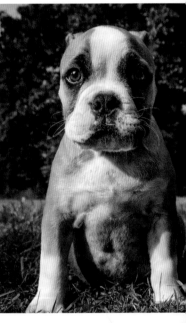
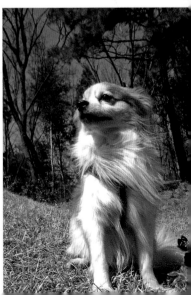

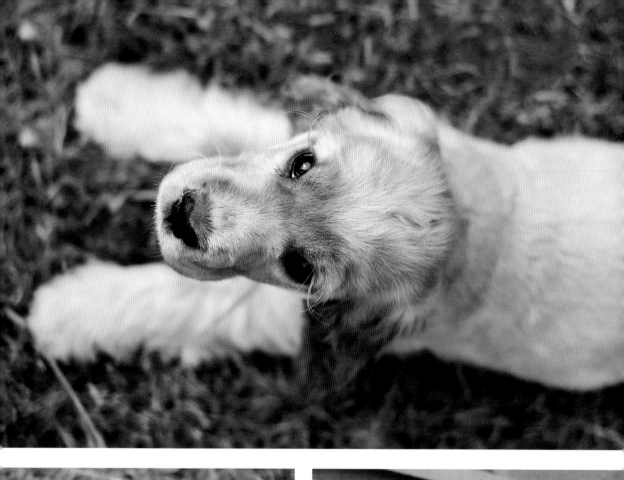

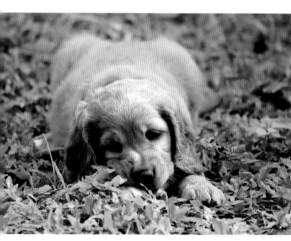

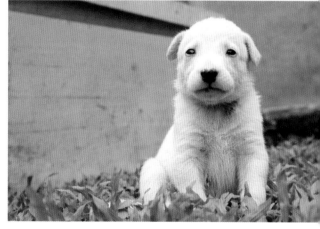

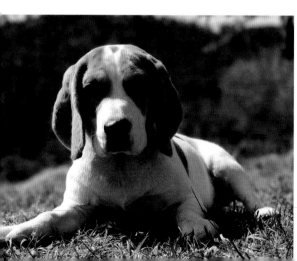

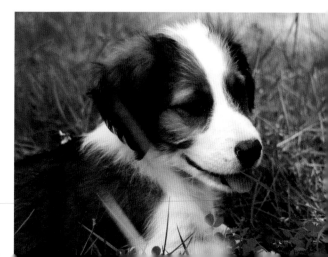

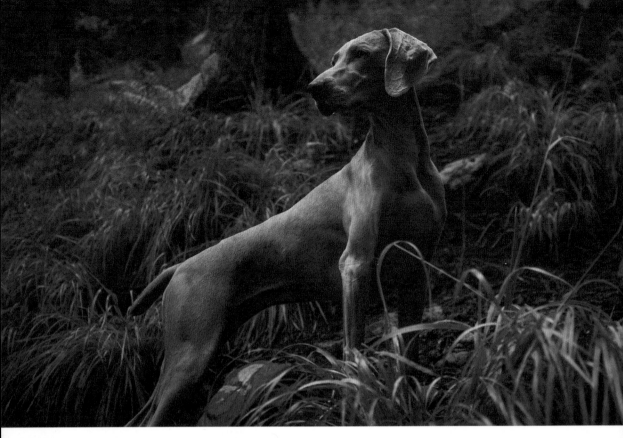

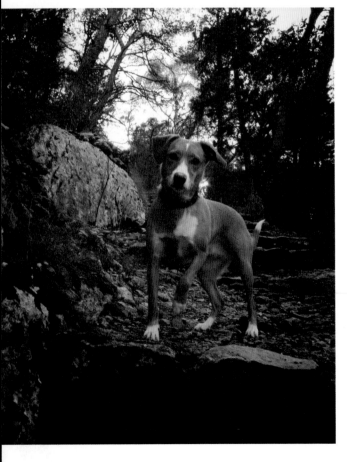

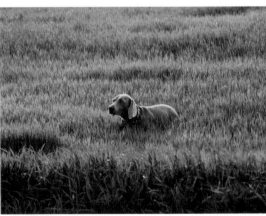

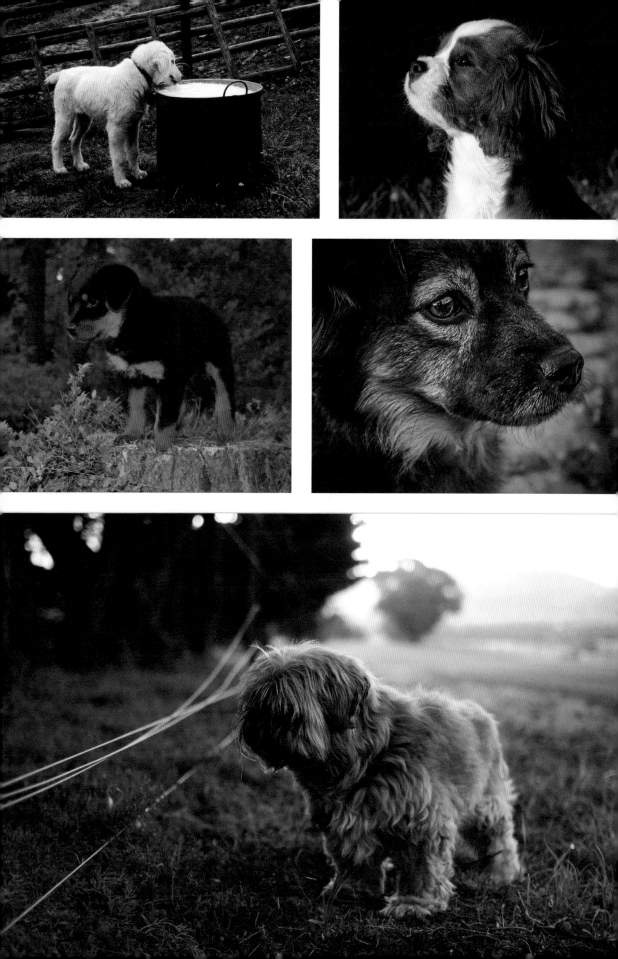

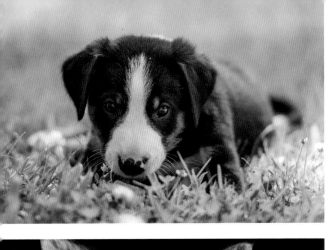
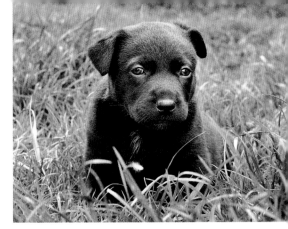
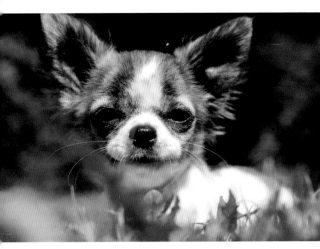
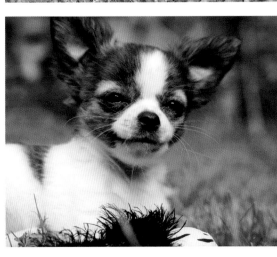
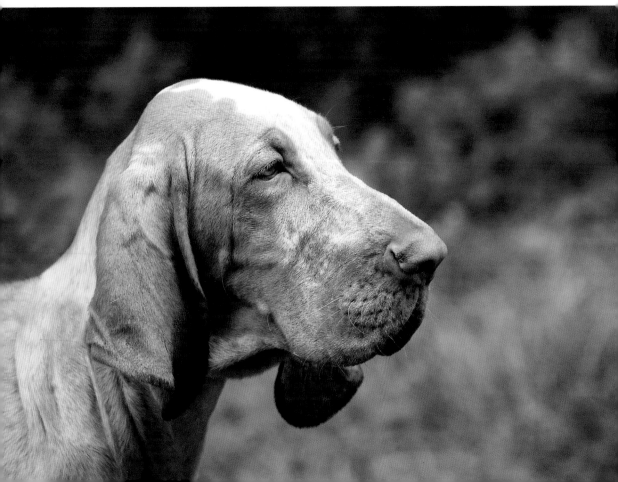

"If there are no dogs in heaven, then when I die I want to go where they went."

—Will Rogers, actor

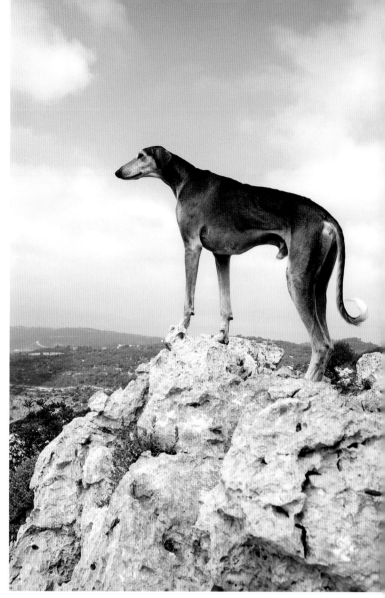

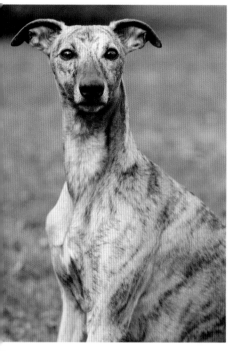

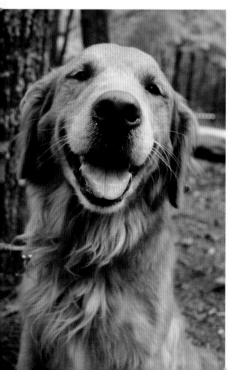

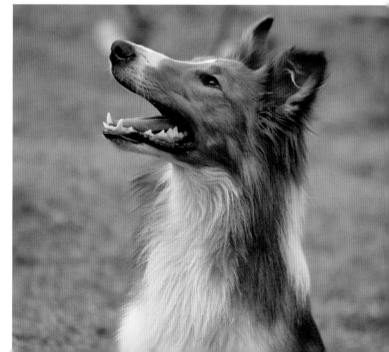

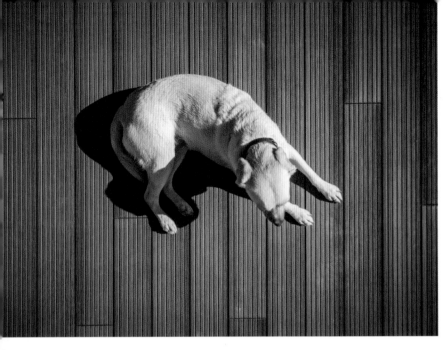

"Happiness is a warm puppy."

—Charles M. Schulz, cartoonist

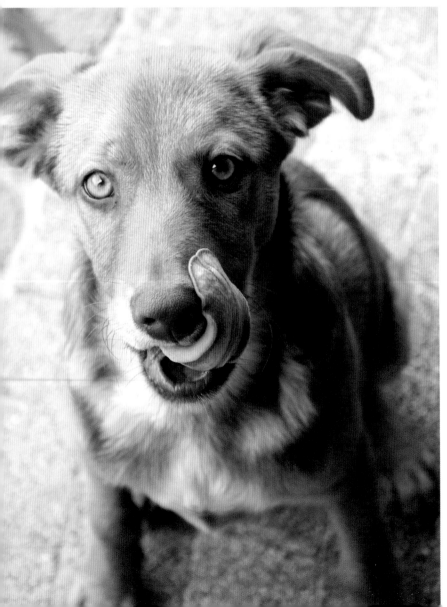

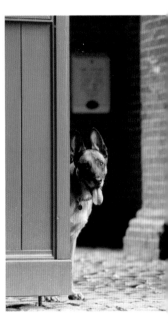

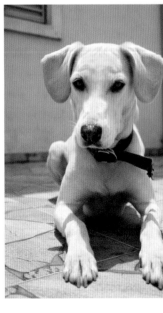

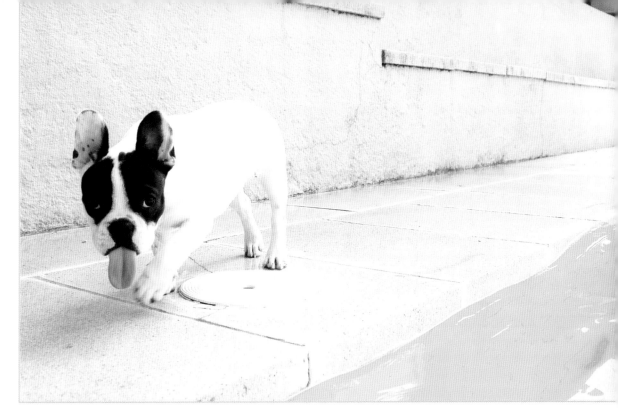

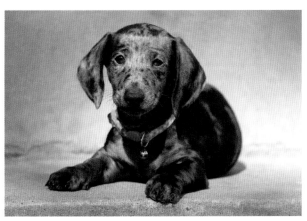

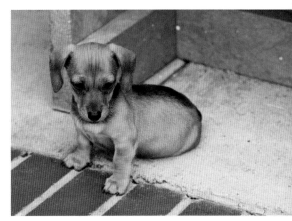

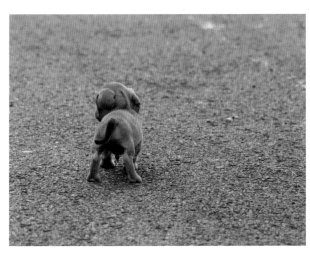

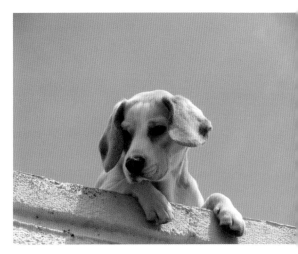

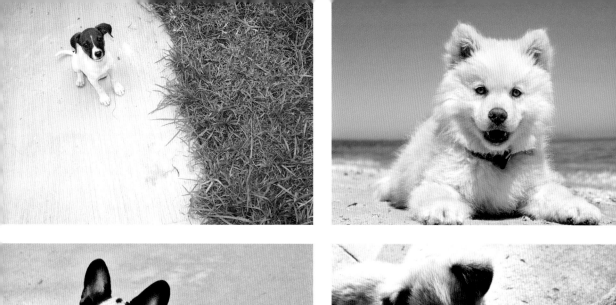

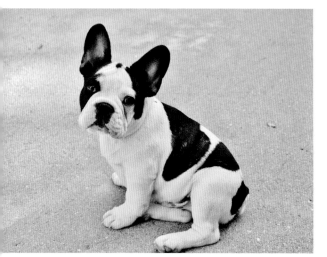

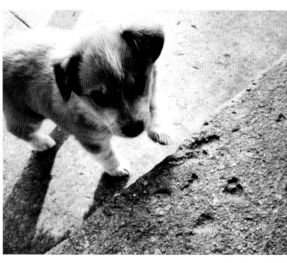

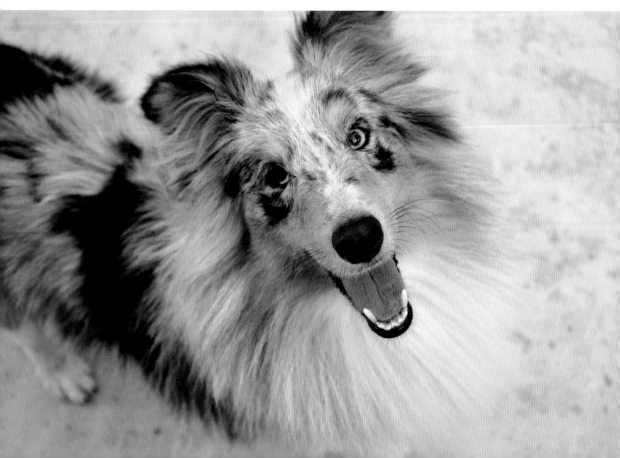

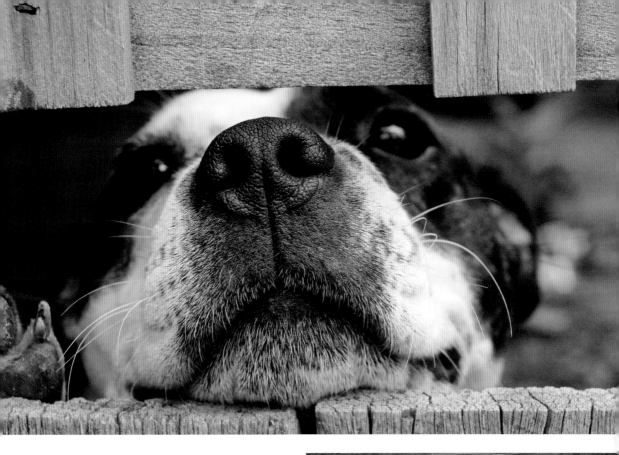

"When the Man waked up he said, 'What is Wild Dog doing here?' And the Woman said, 'His name is not Wild Dog anymore, but the First Friend, because he will be our friend for always and always and always."

—Rudyard Kipling, author

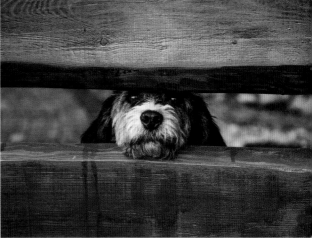

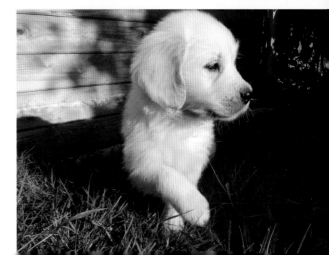

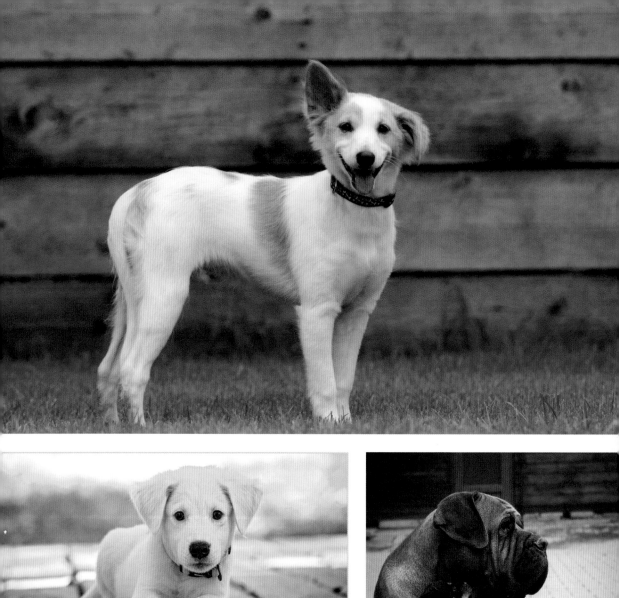
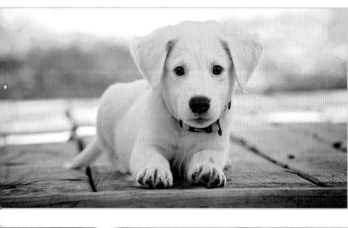
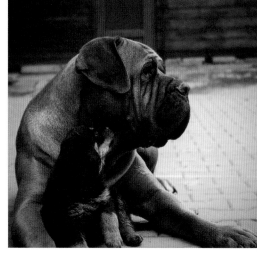
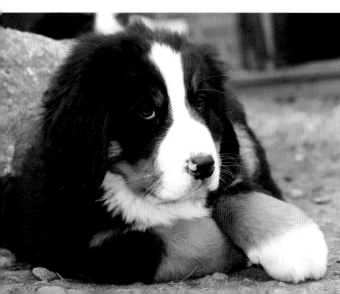
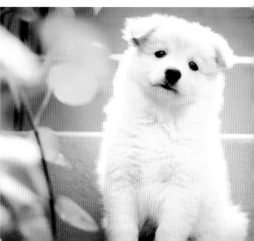

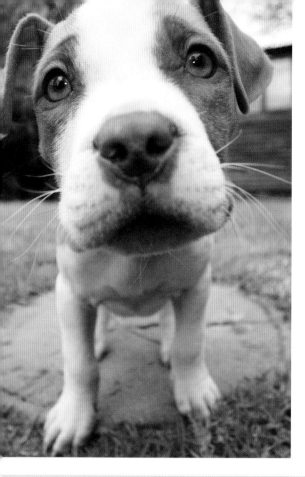
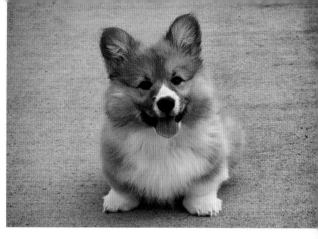
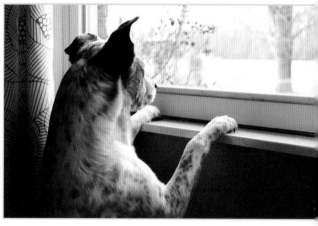
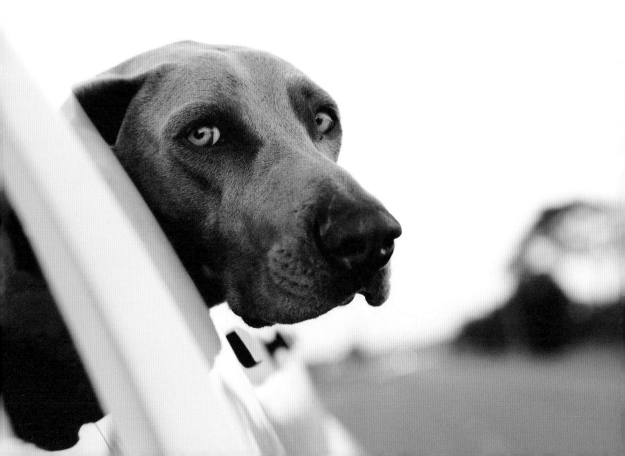

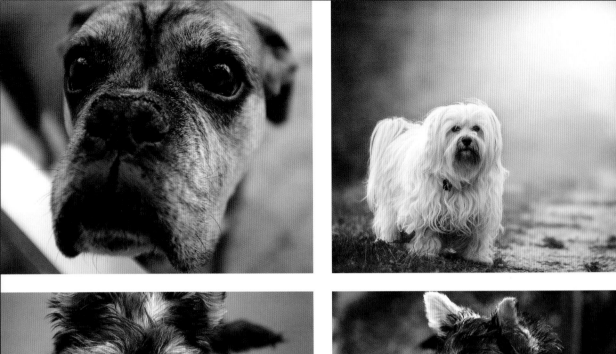

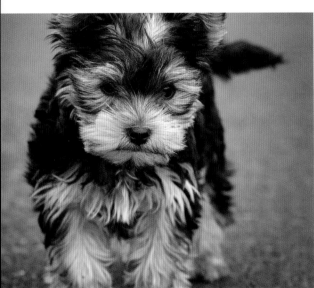

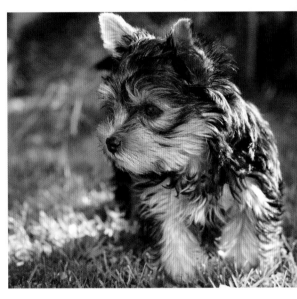

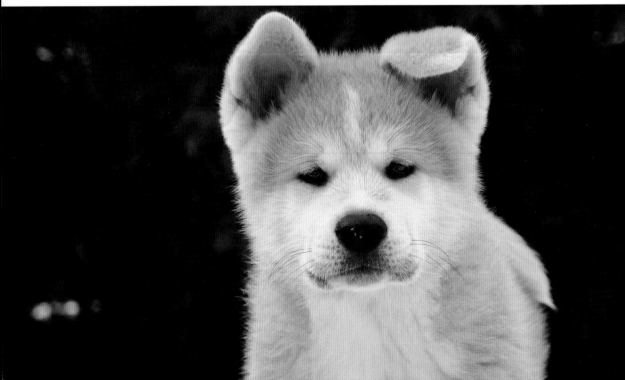

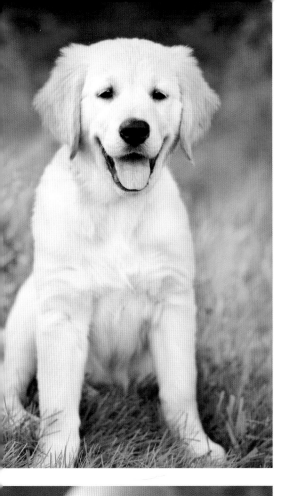

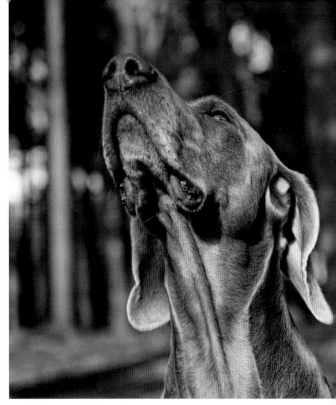

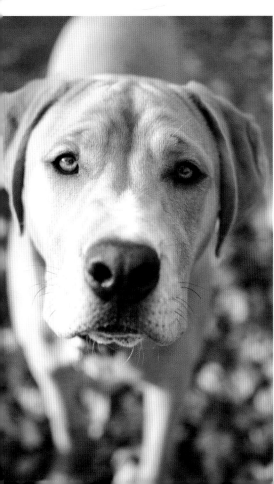

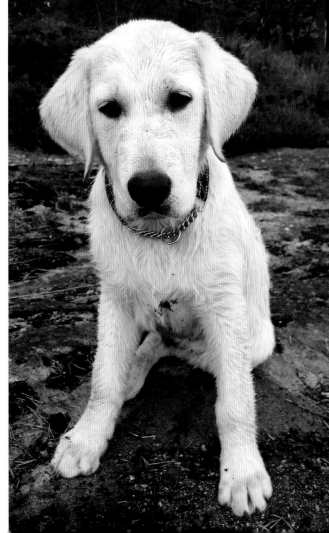

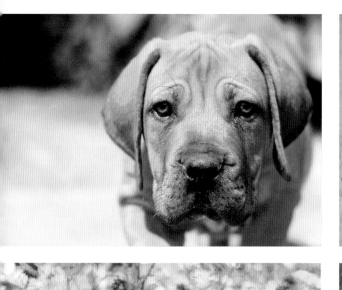
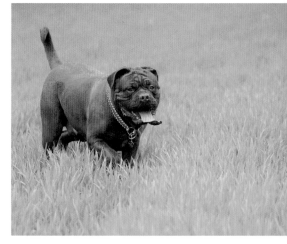

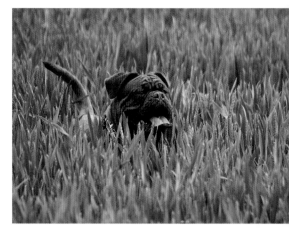
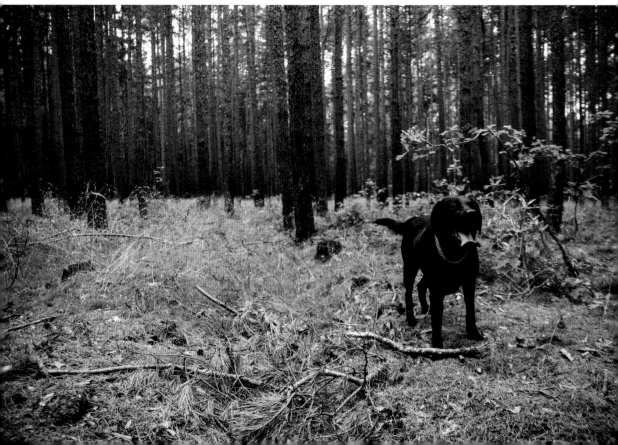

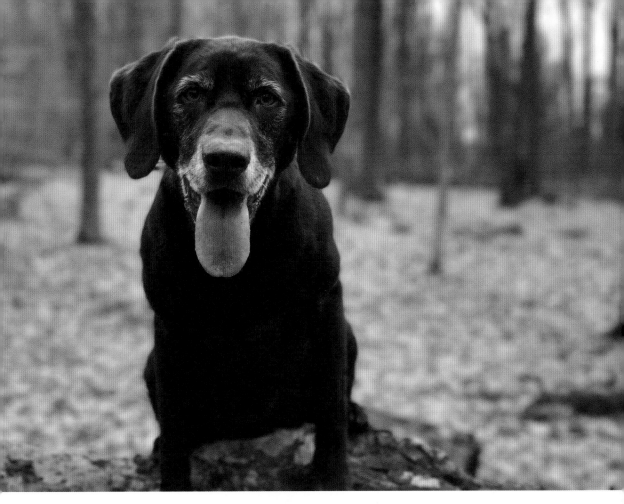

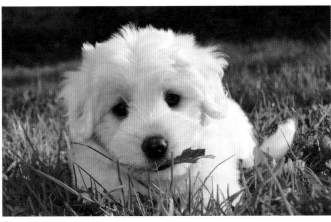

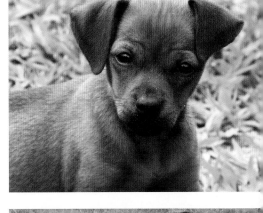

"You can say any foolish thing to a dog, and the dog will give you a look that says, 'Wow, you're right! I never would've thought of that!'"

—Dave Barry, author

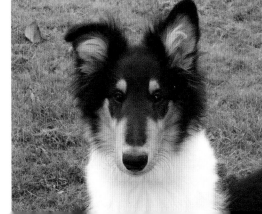

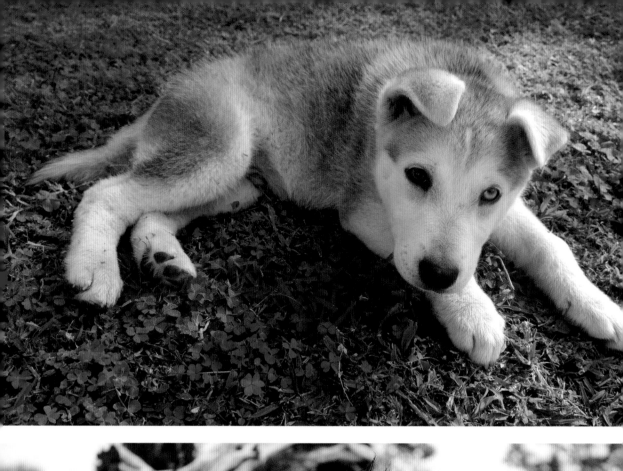
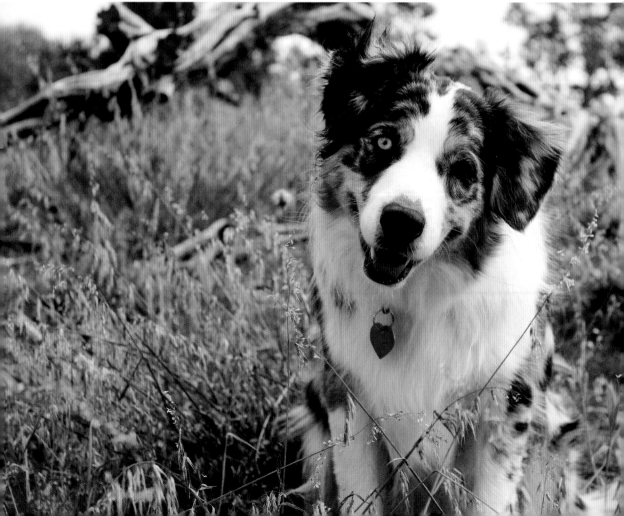

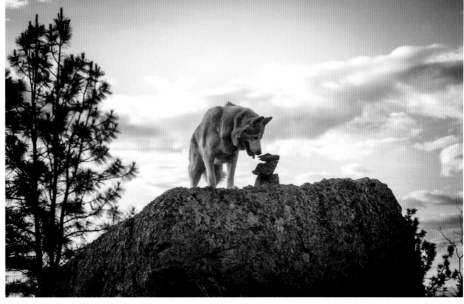
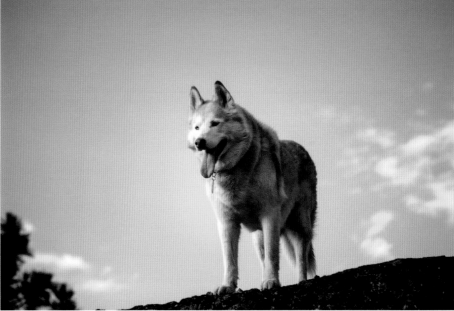
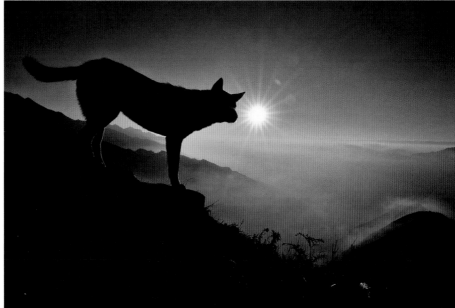

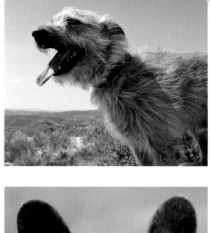

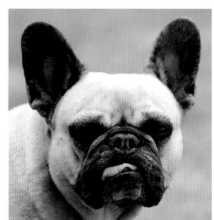

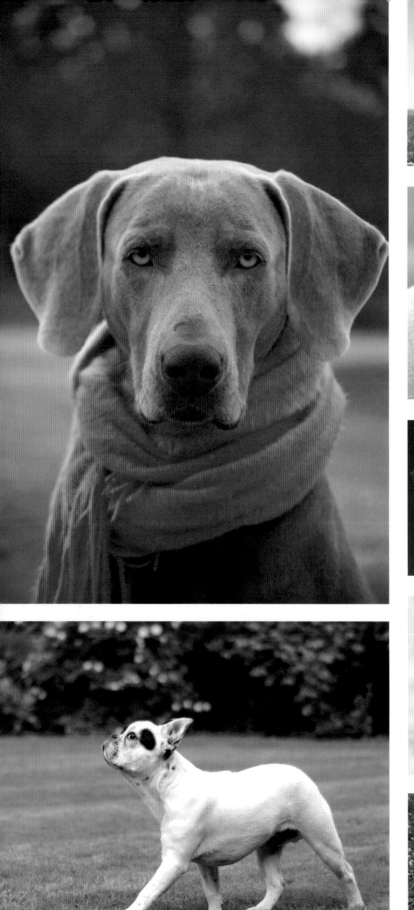

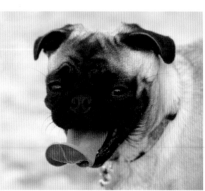

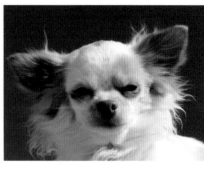

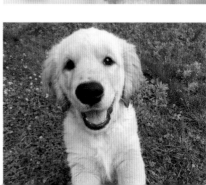

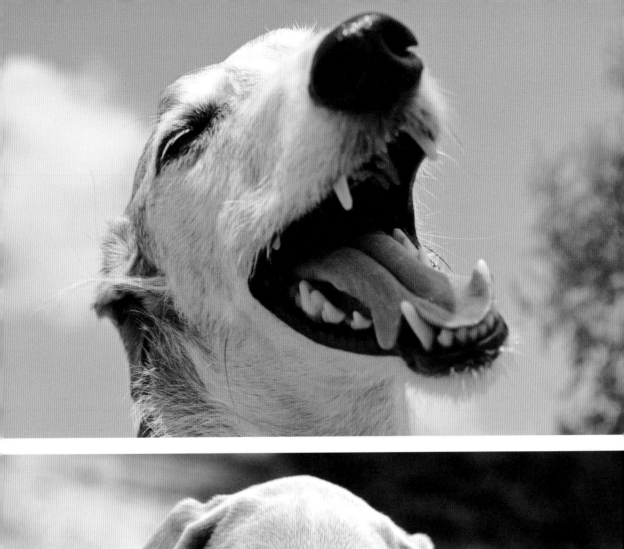
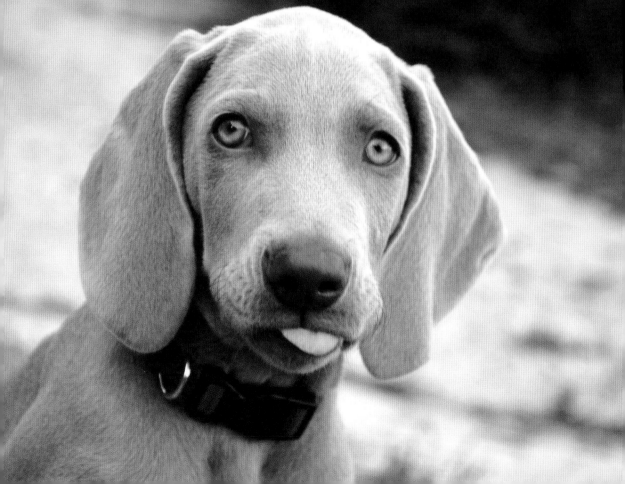

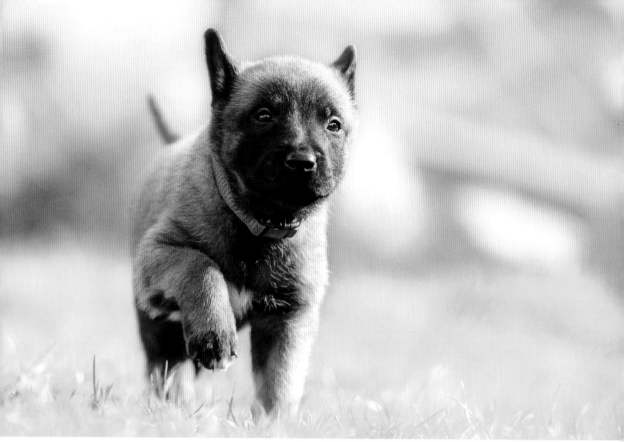

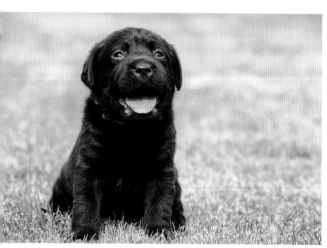

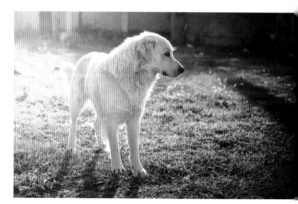

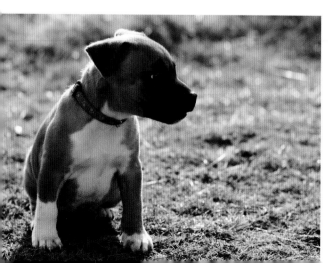

"You think dogs
will not be in heaven?
I tell you, they will
be there long before
any of us."

–Robert Louis Stevenson, author

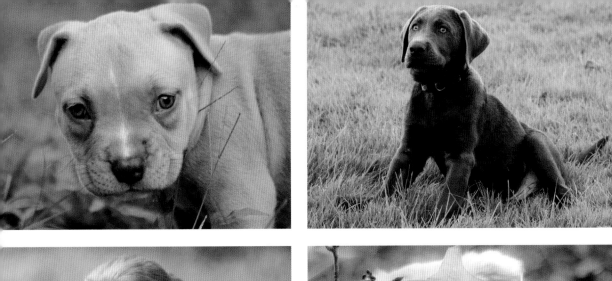

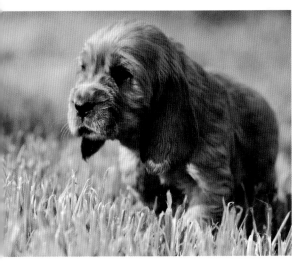

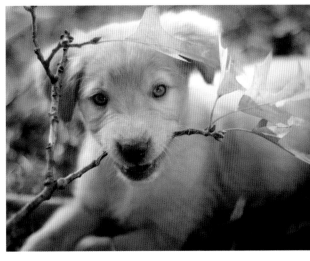

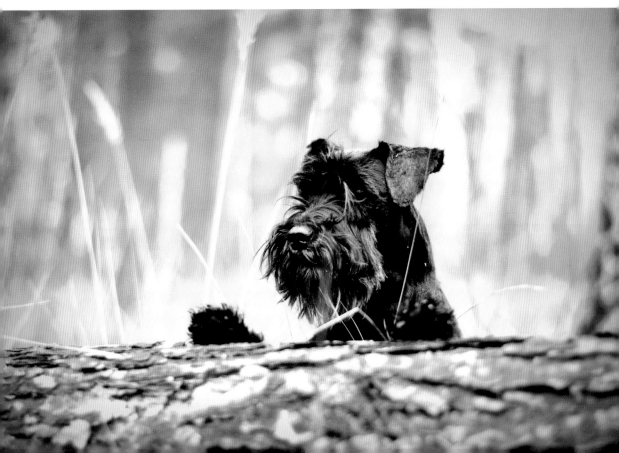

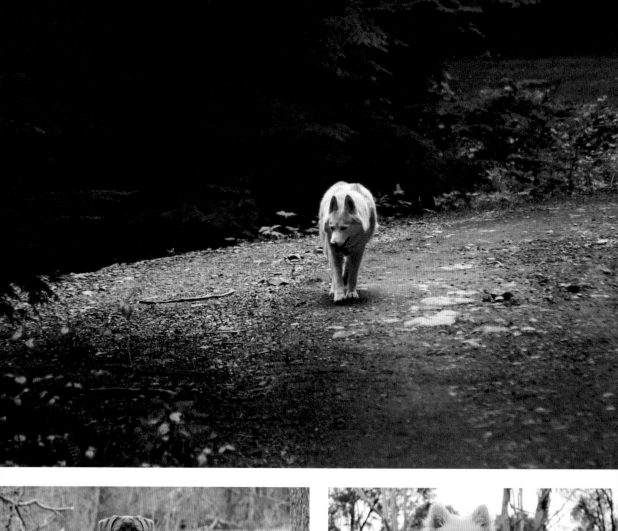

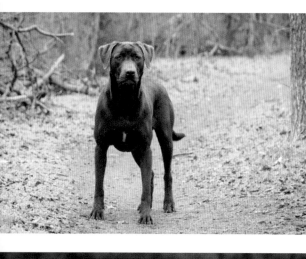

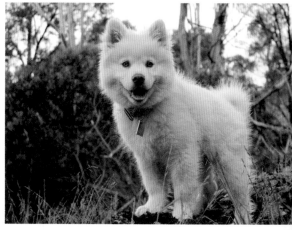

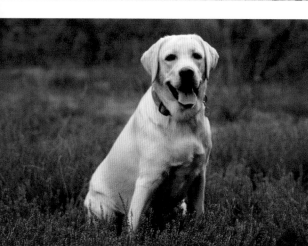

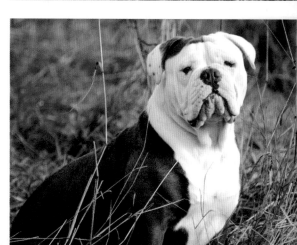

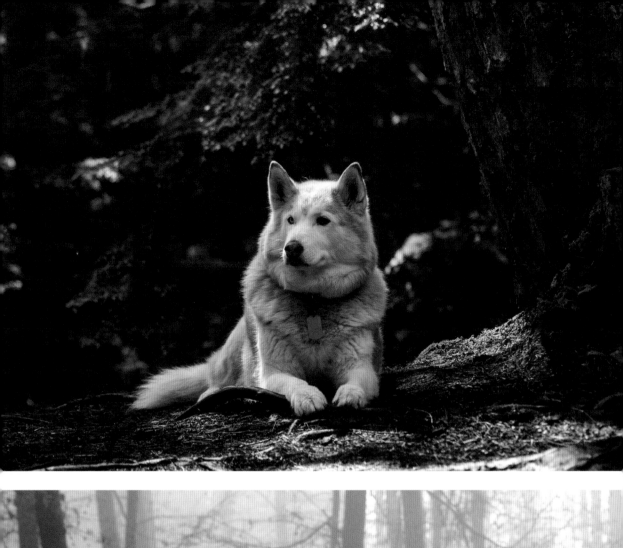

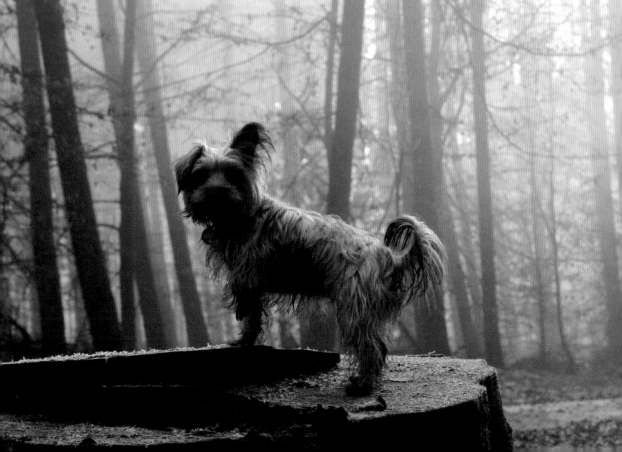

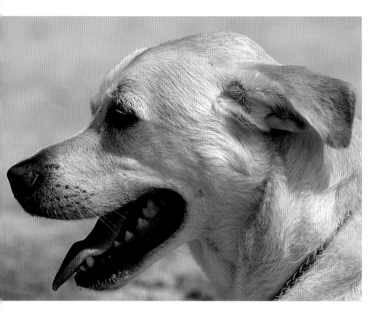
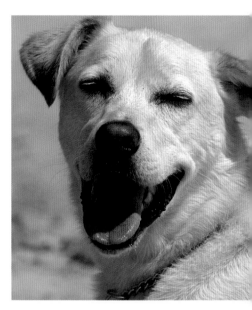
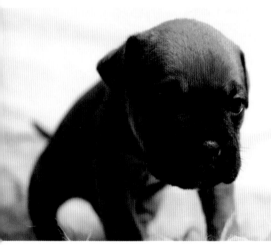
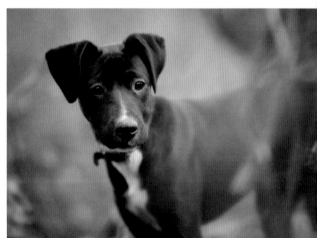
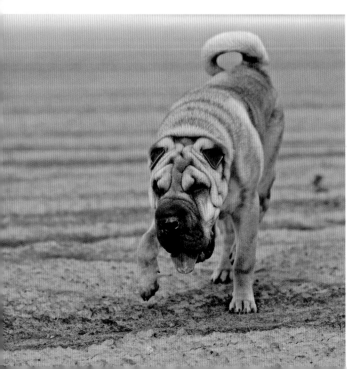
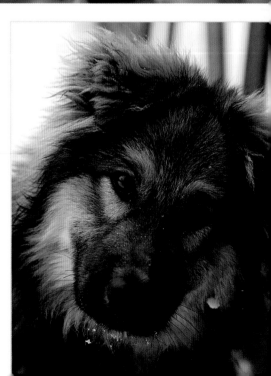

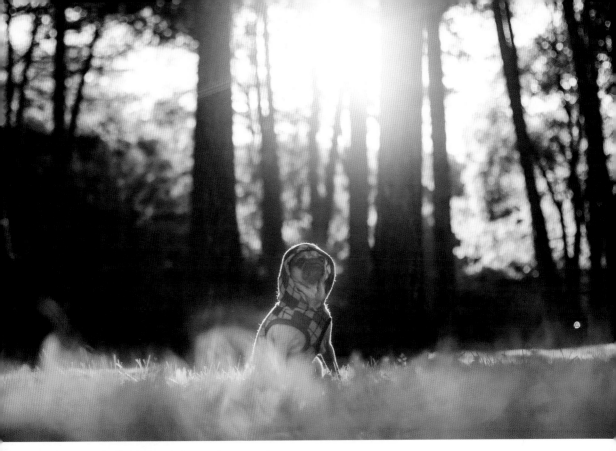

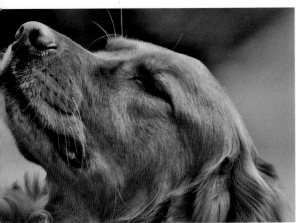

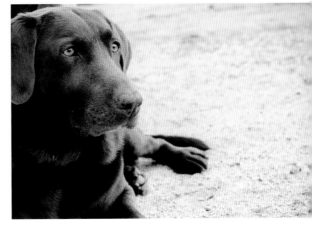

"I've seen a look in dogs' eyes, a quickly vanishing look of amazed contempt, and I am convinced that basically dogs think humans are nuts."

—John Steinbeck, author

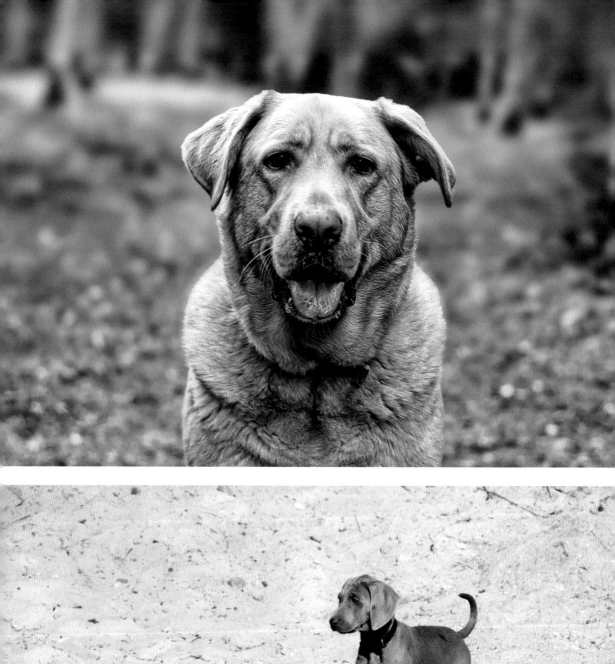
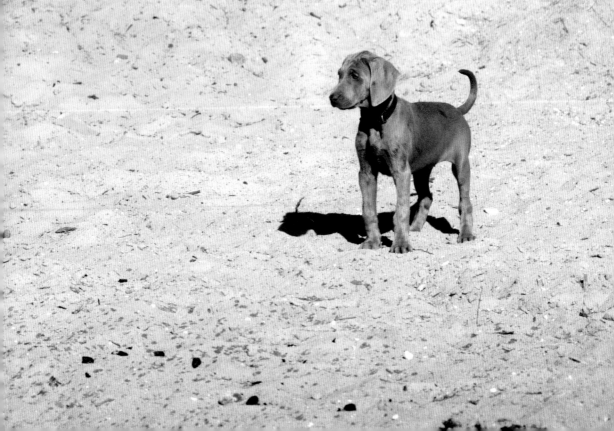

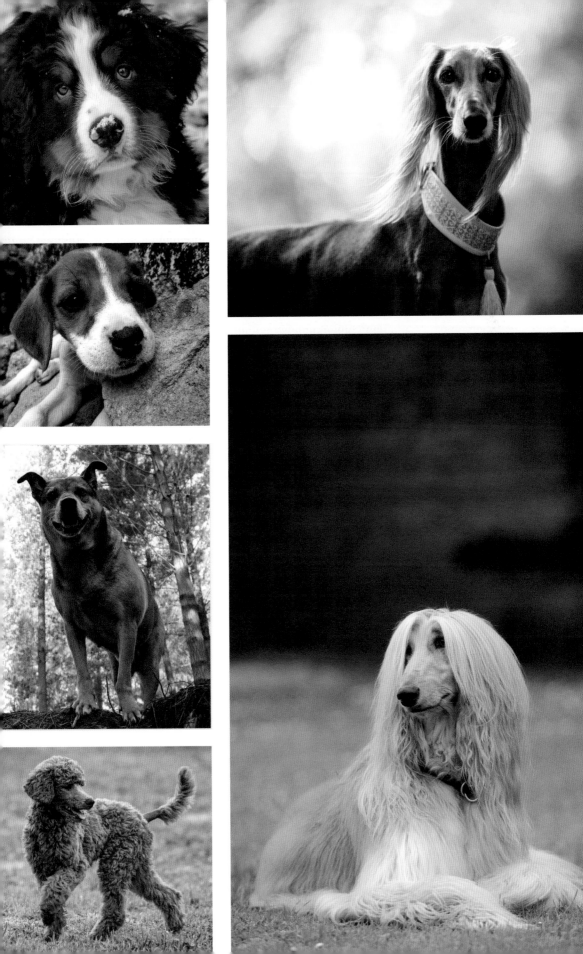

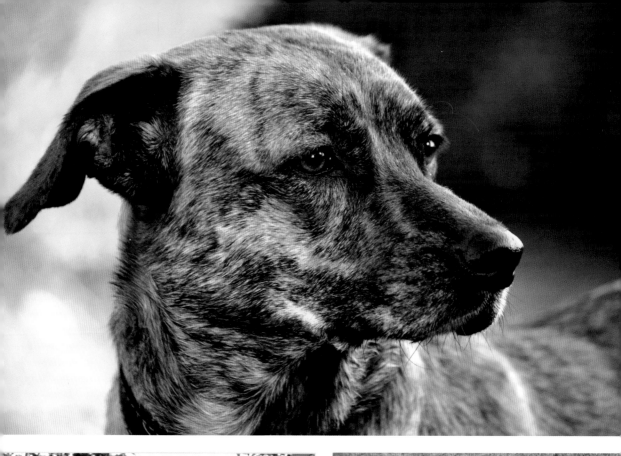

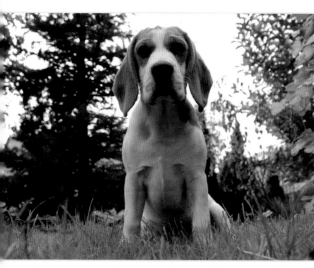

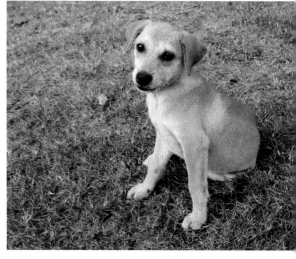

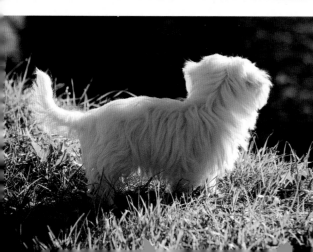

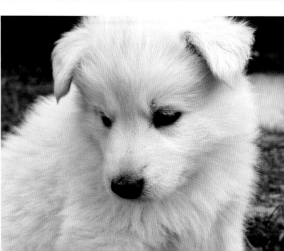

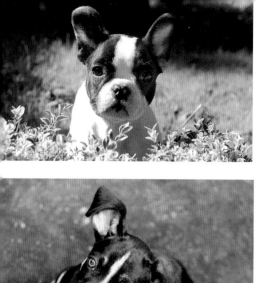
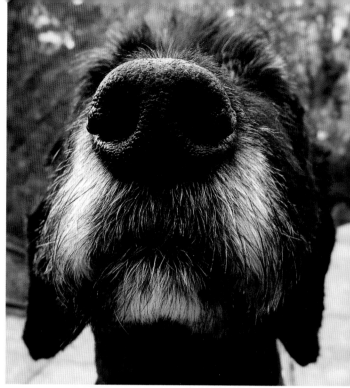
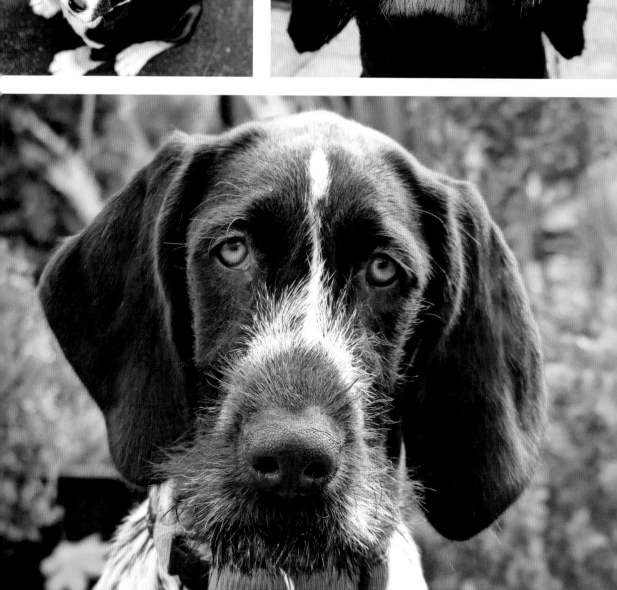

4. My Favorite Things

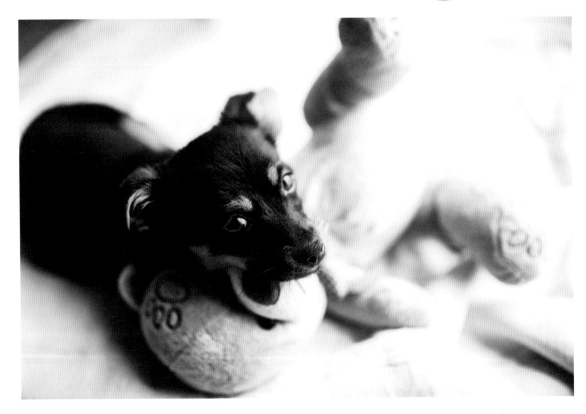

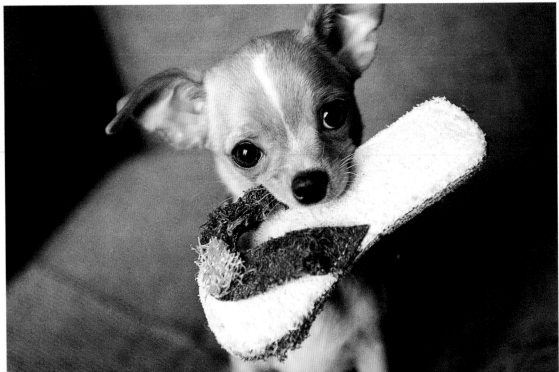

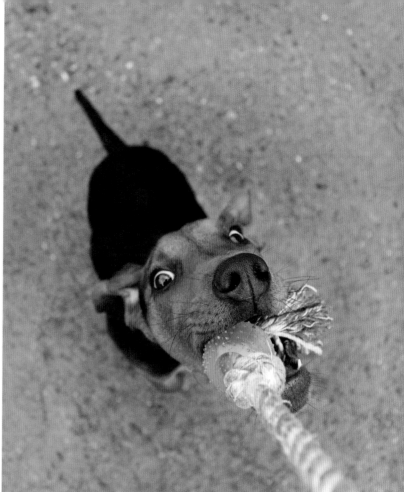

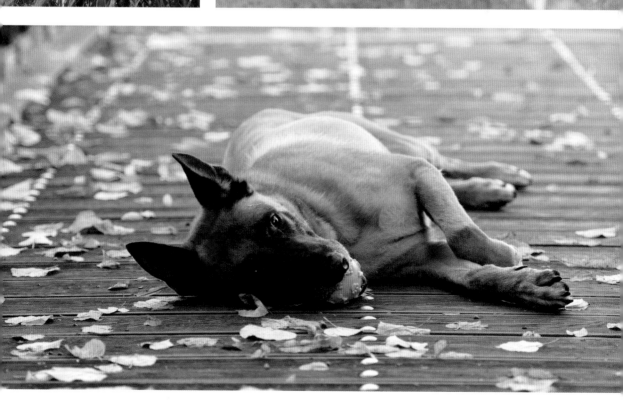

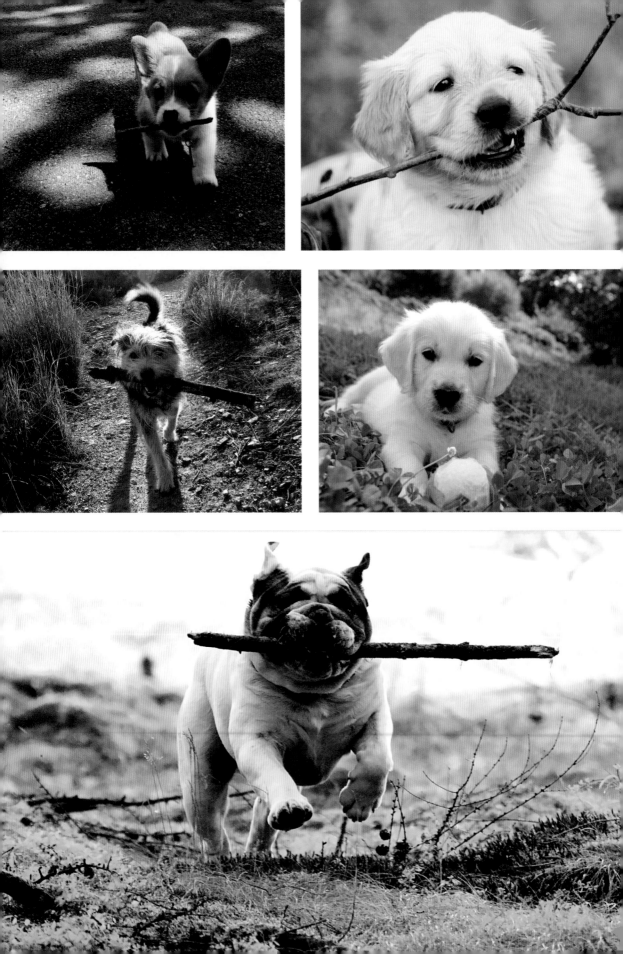

5. Sweet and Silly Faces

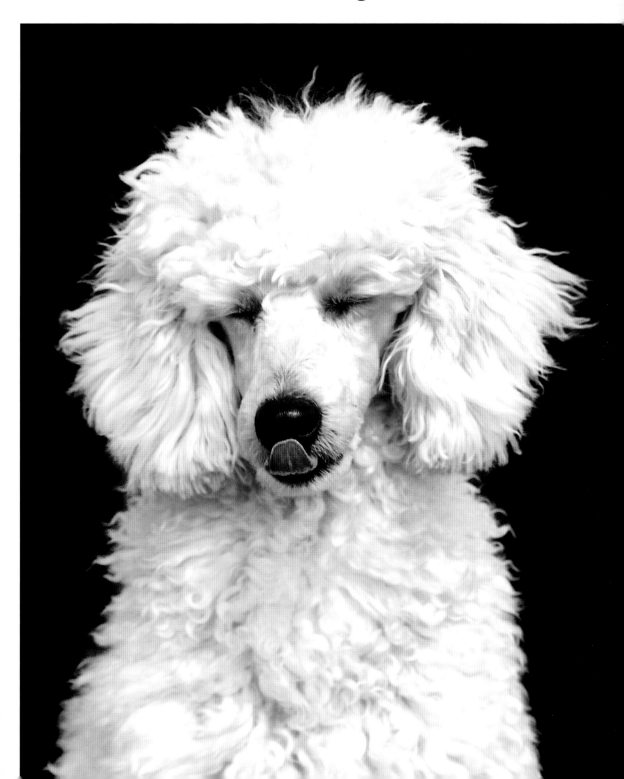

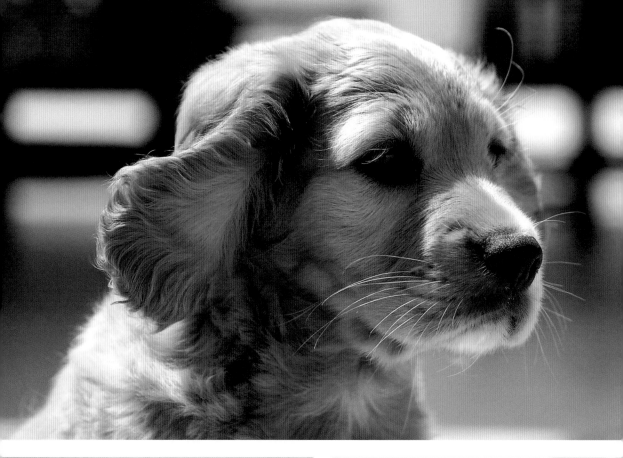

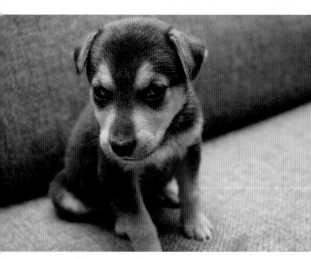

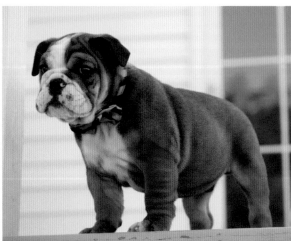

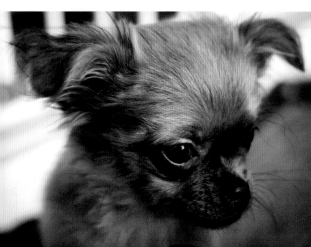

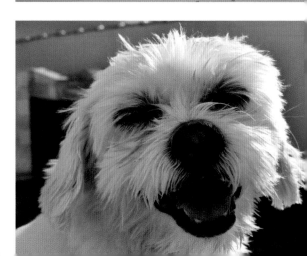

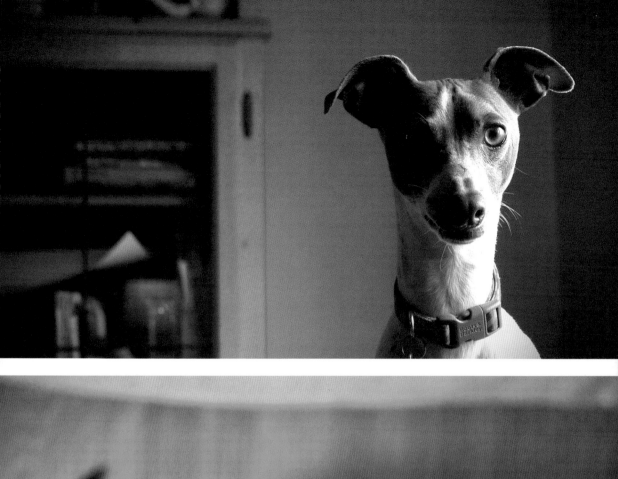
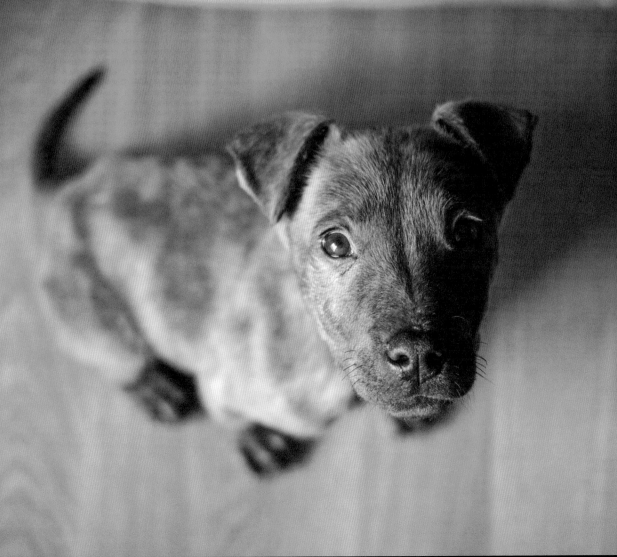

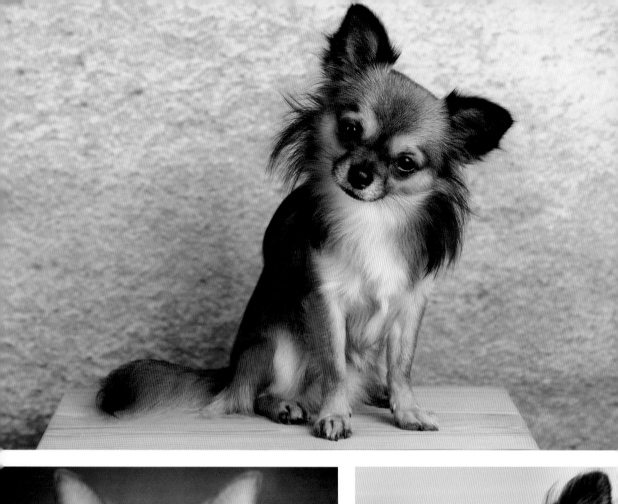

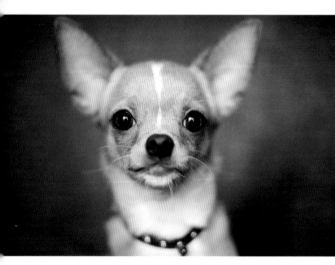

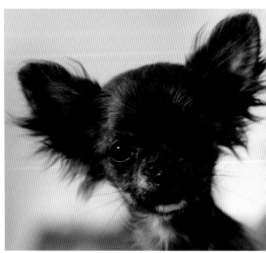

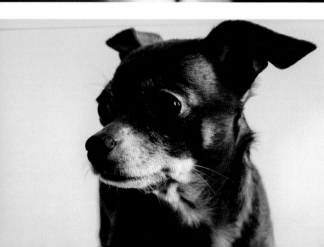

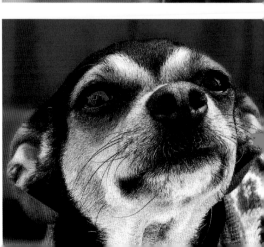

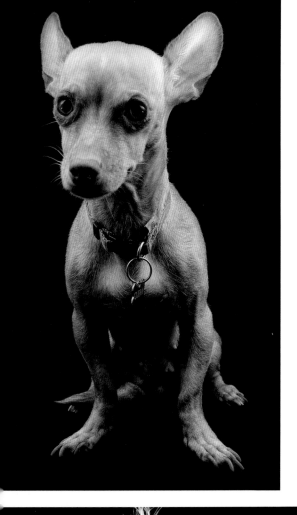
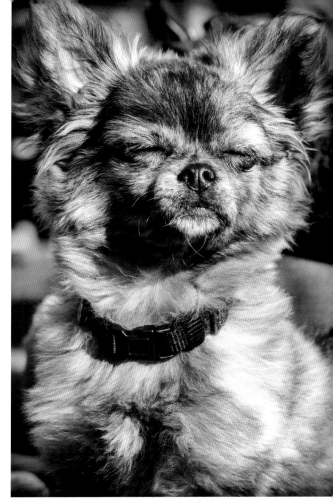
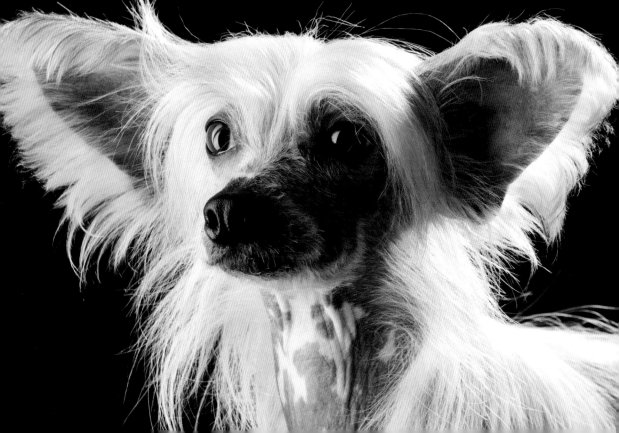

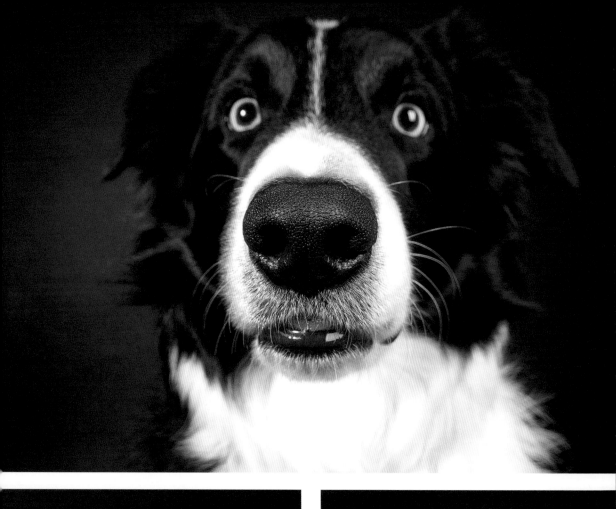

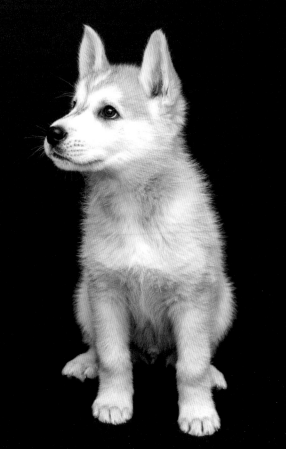

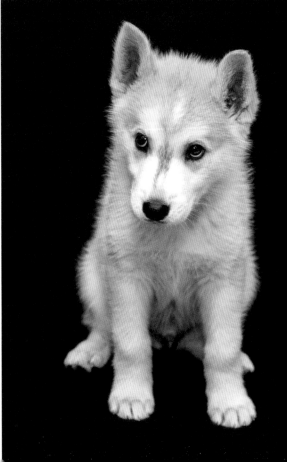

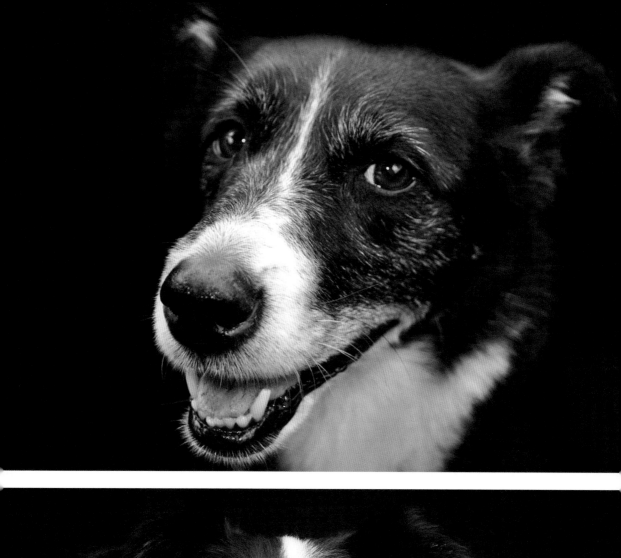

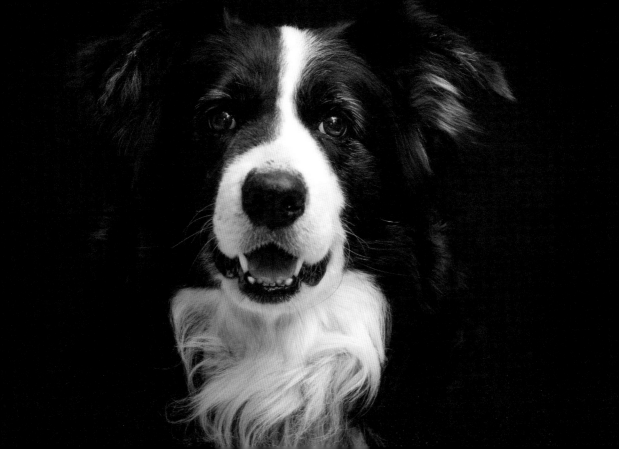

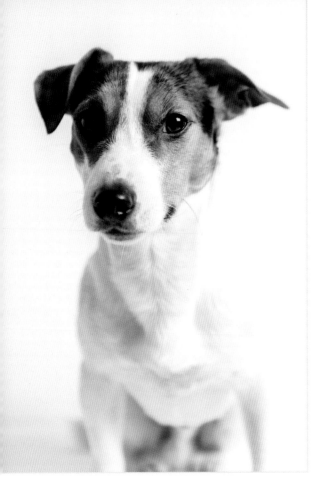
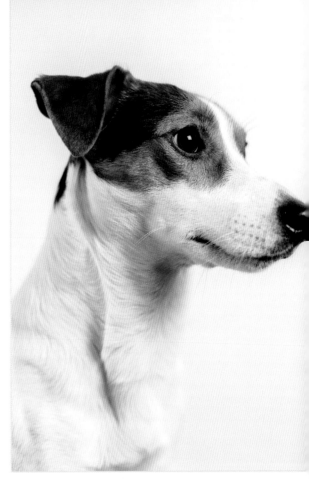
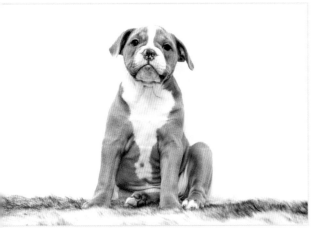
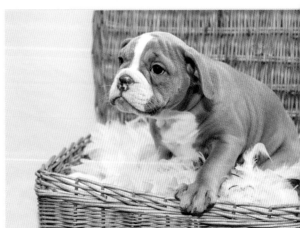

"The average dog is a nicer person than the average person."

—Andy Rooney, humorist

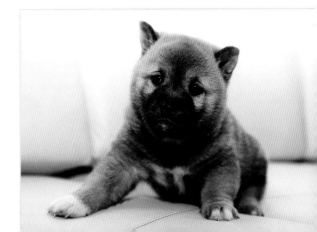

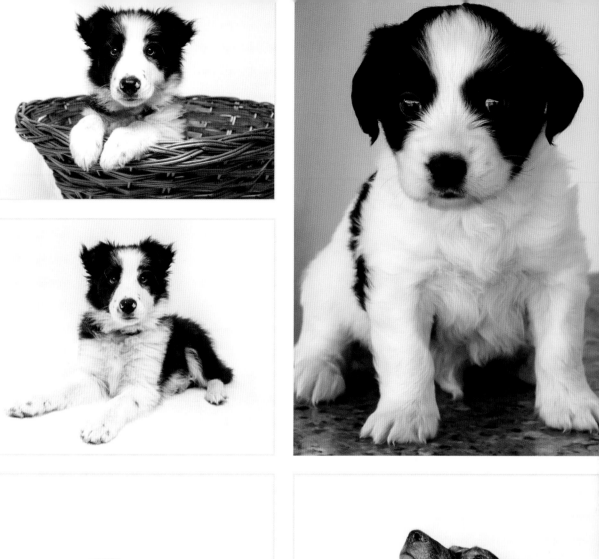

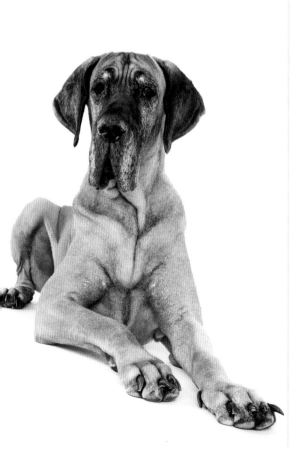

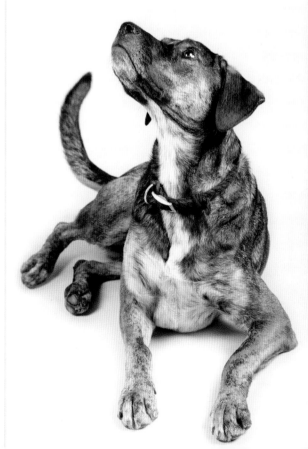

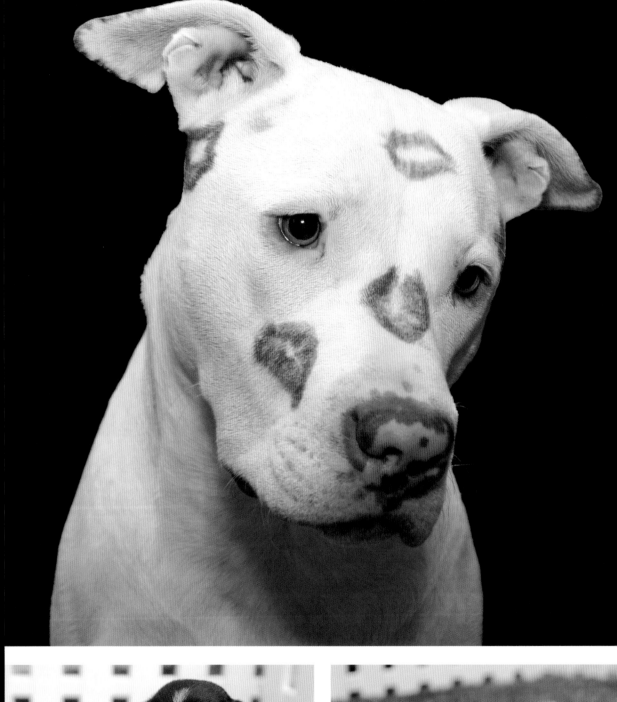

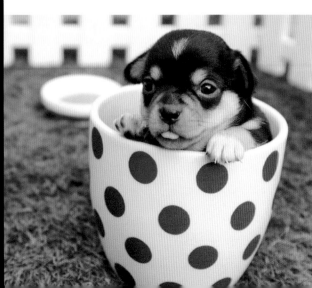

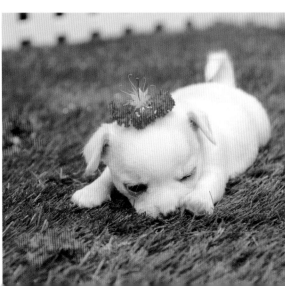

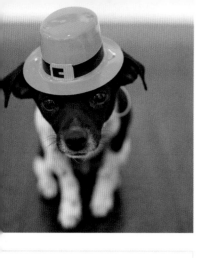
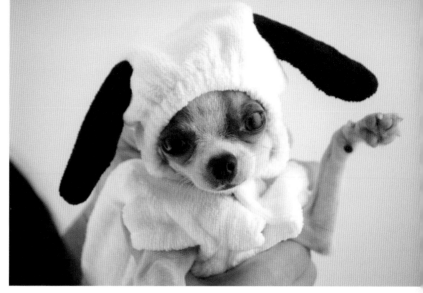
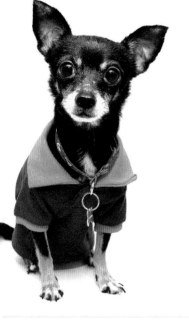
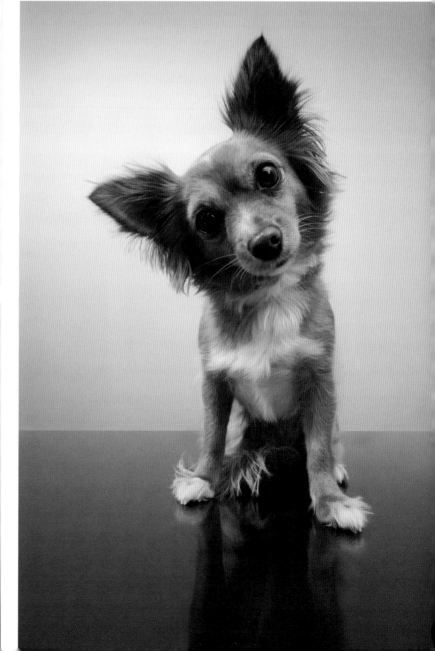
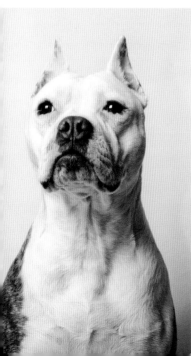

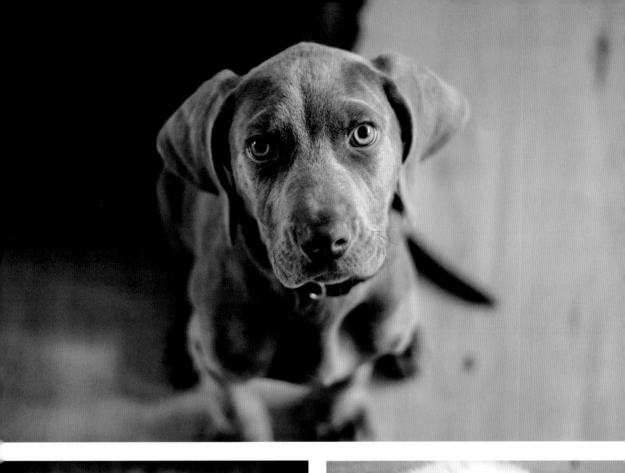

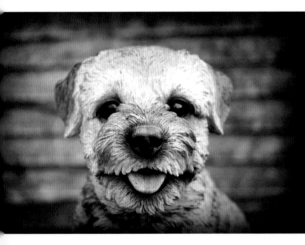

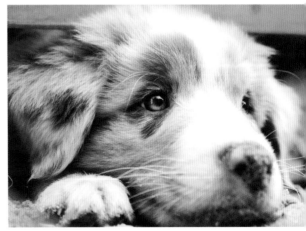

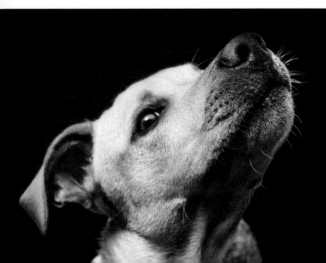

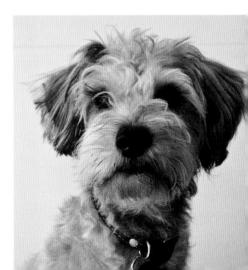

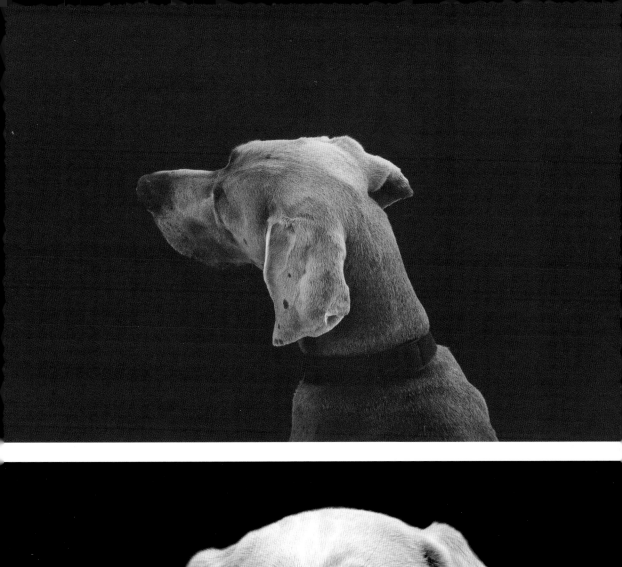

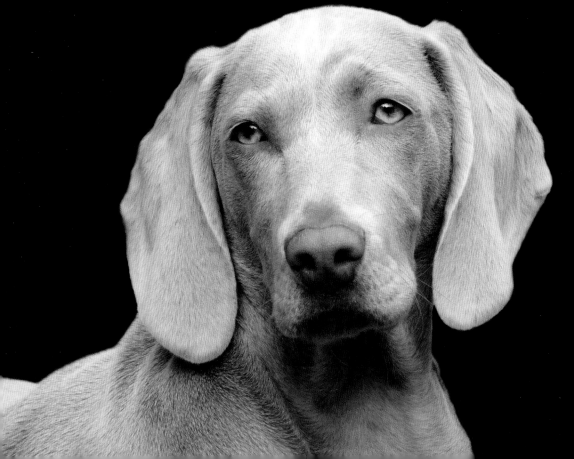

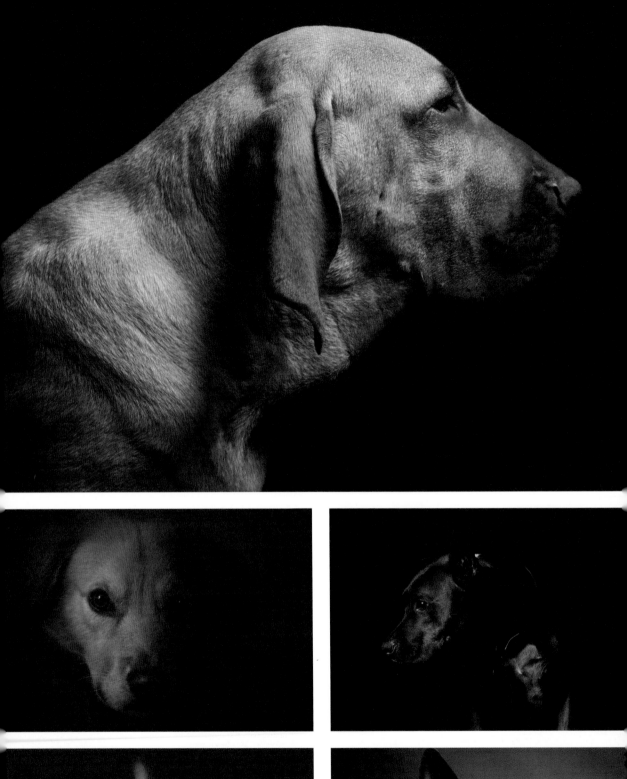
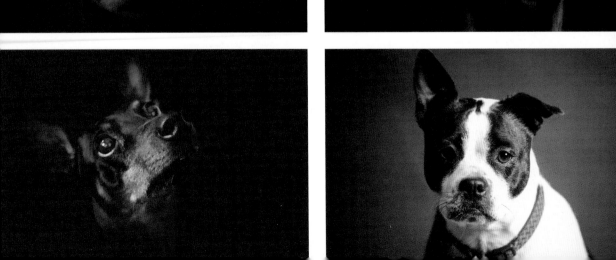

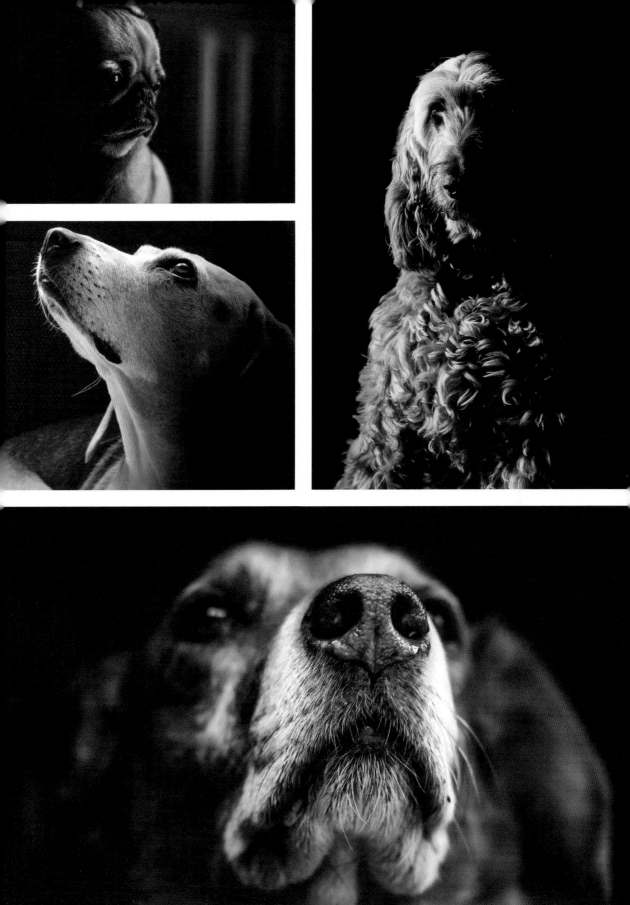

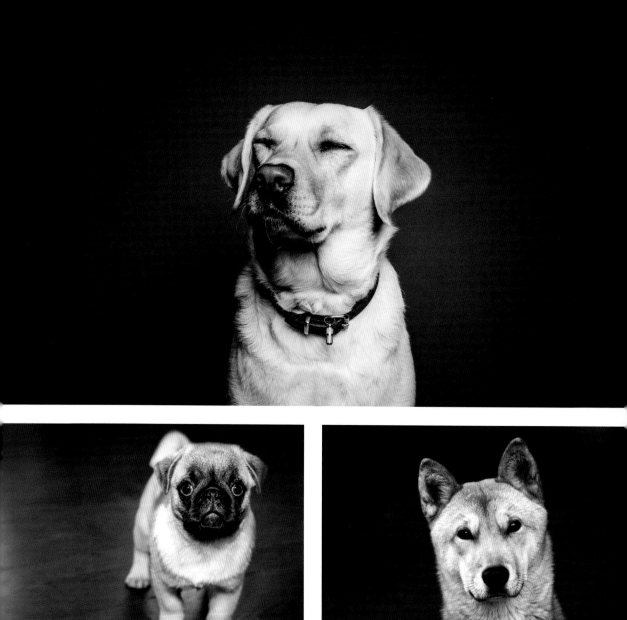
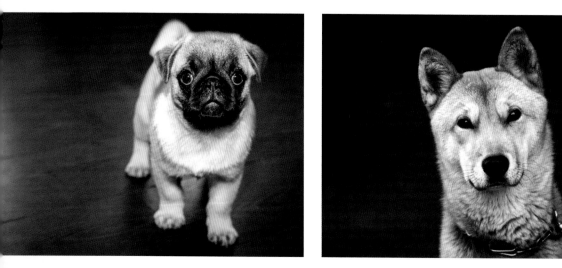
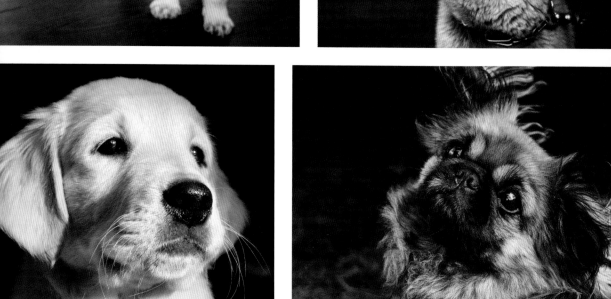

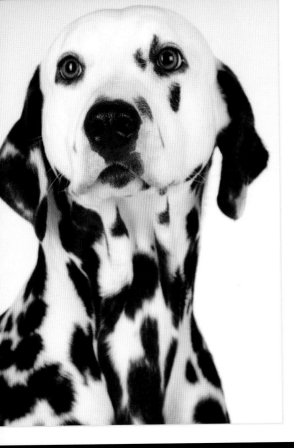

"Once you have had a wonderful dog, a life without one is a life diminished."

—Dean Koontz, author

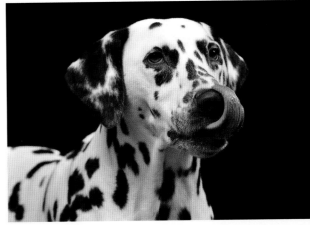

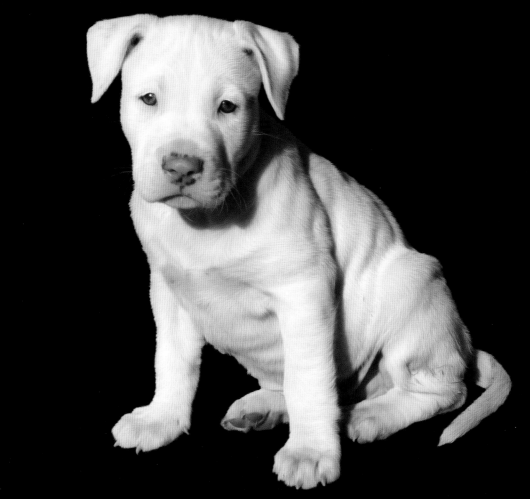

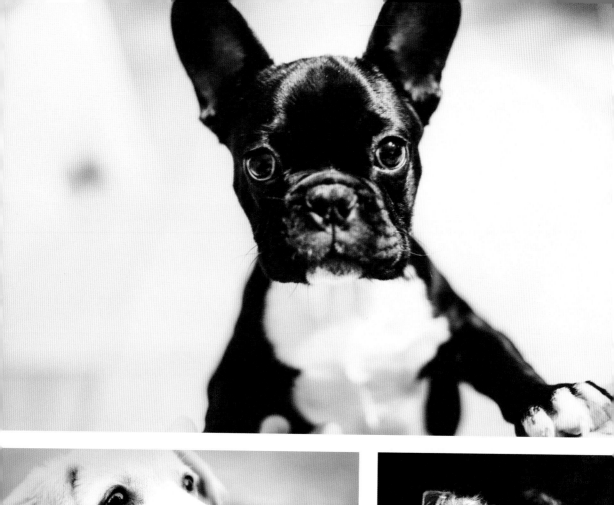

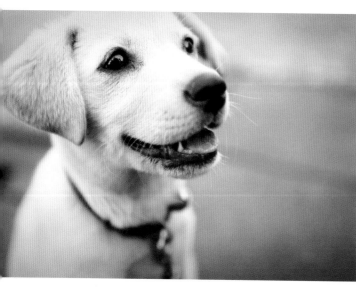

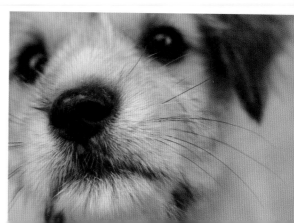

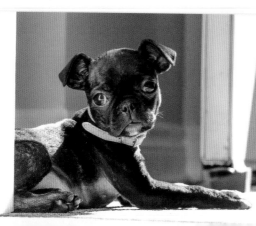

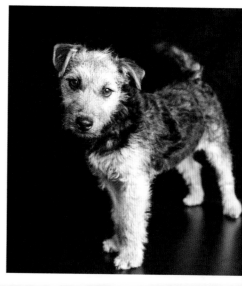

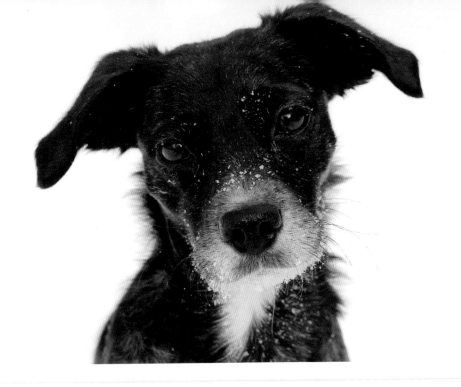
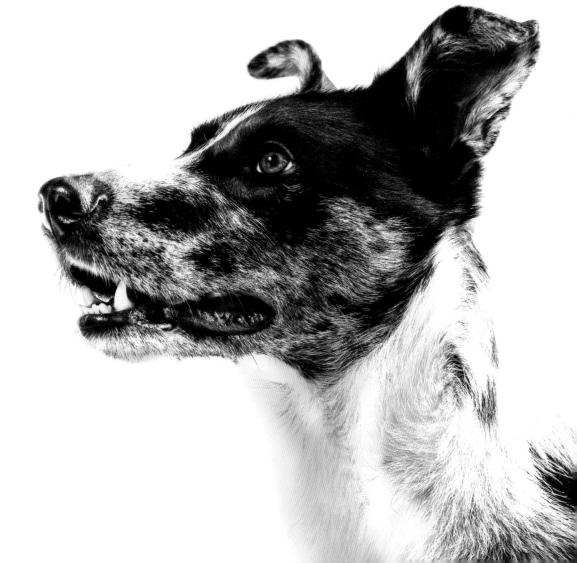

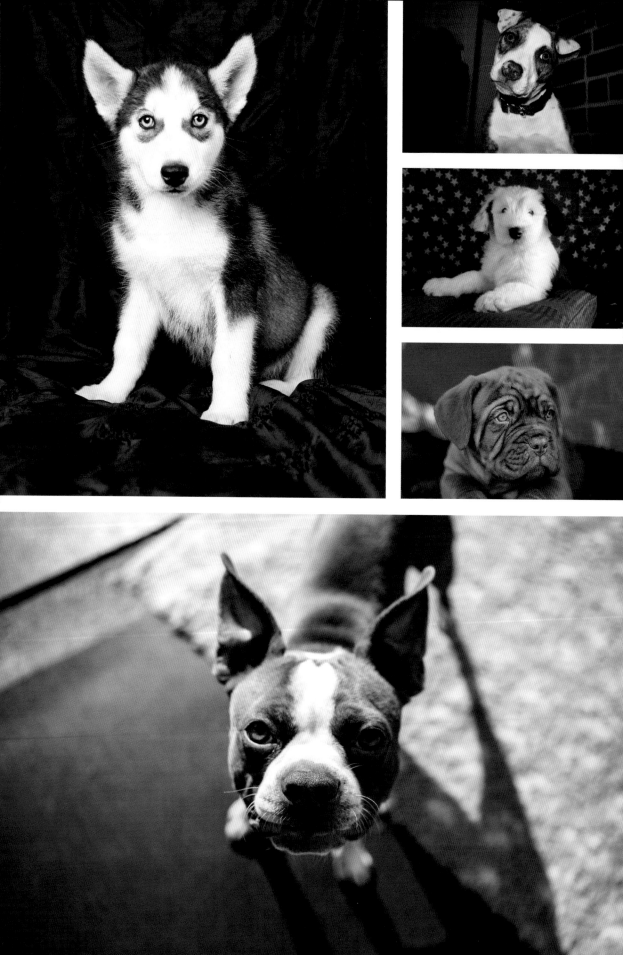

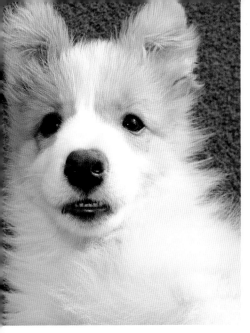

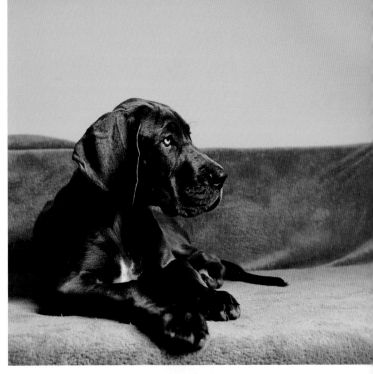

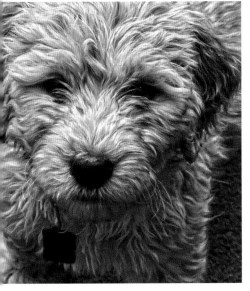

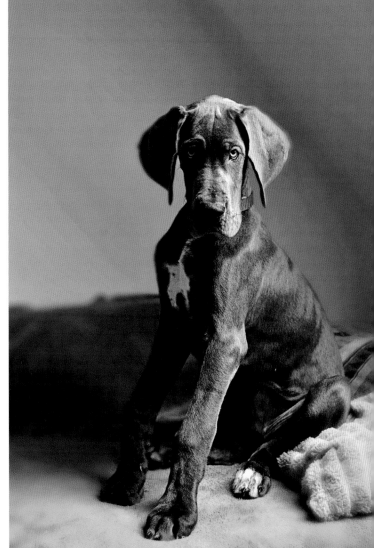

"A dog teaches
a boy fidelity,
perseverance,
and to turn
around three
times before
lying down."

—Robert Benchley, humorist

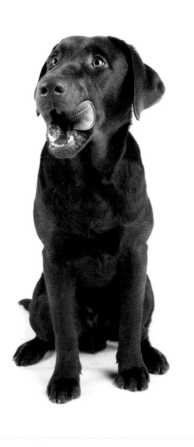
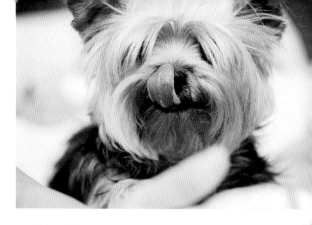
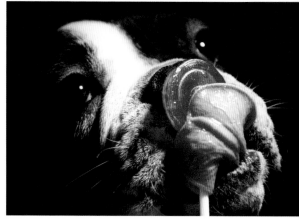
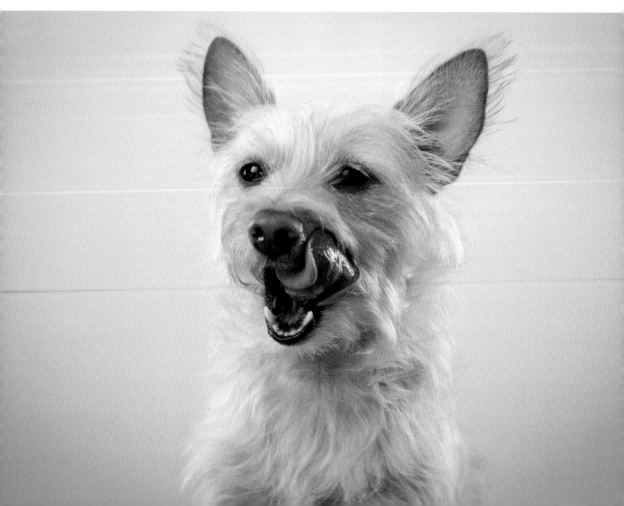

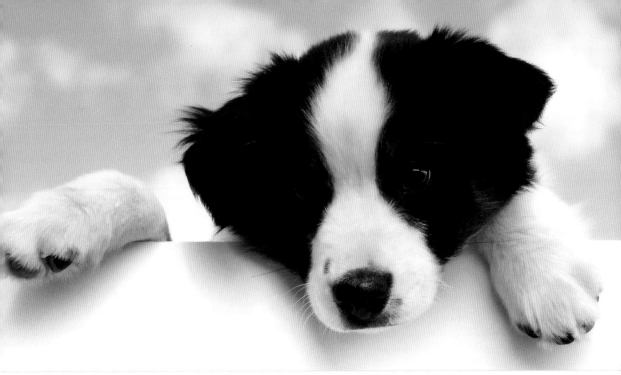

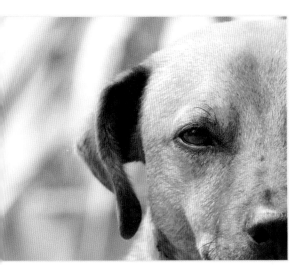

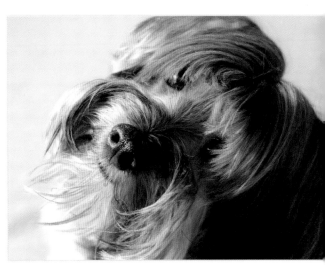

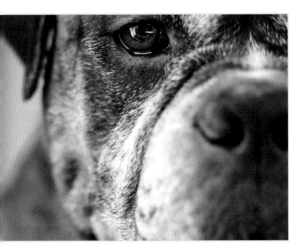

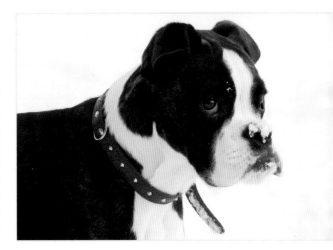

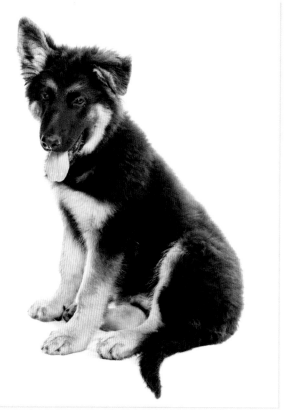

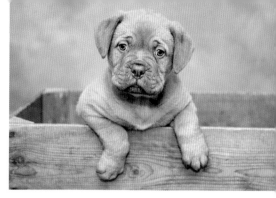

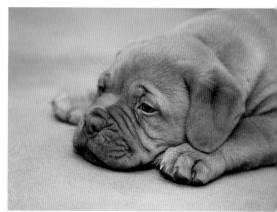

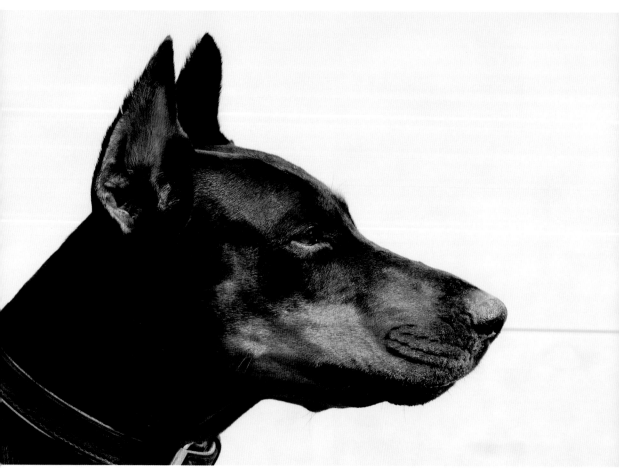

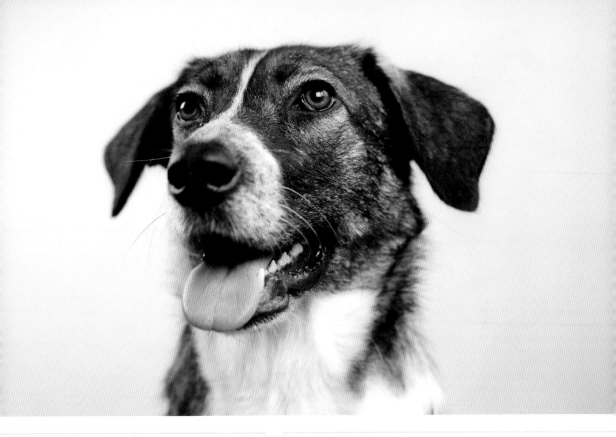

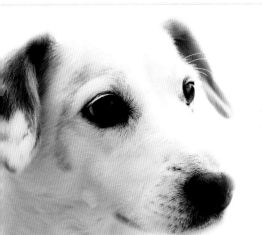

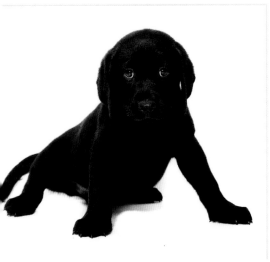

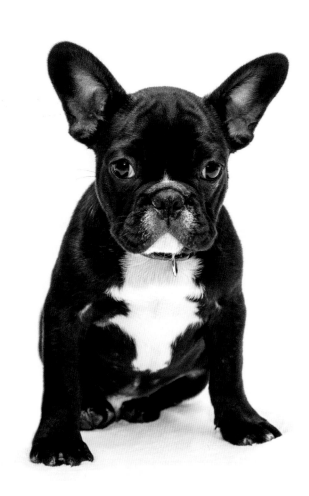

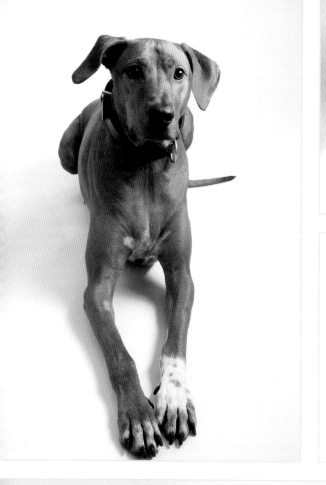
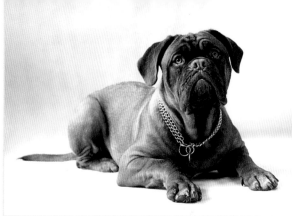
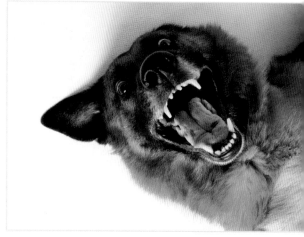
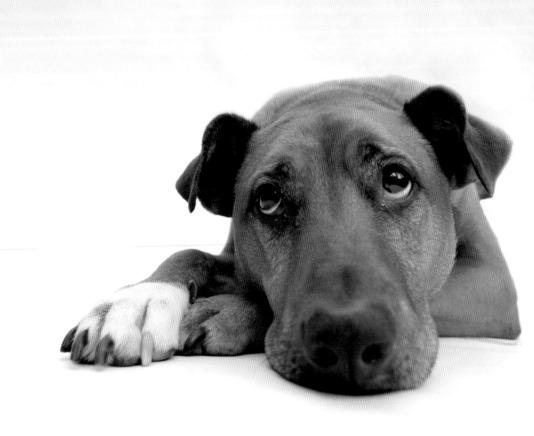

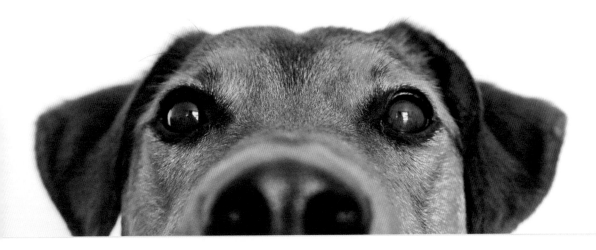

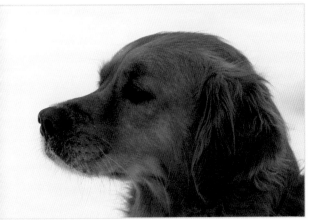

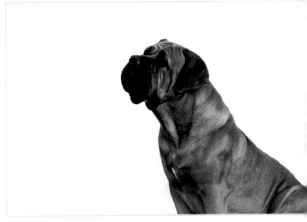

"Dogs got
personality.
Personality
goes a long
way."

–Quentin Tarantino, director

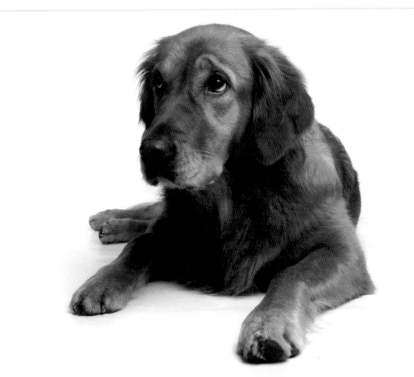

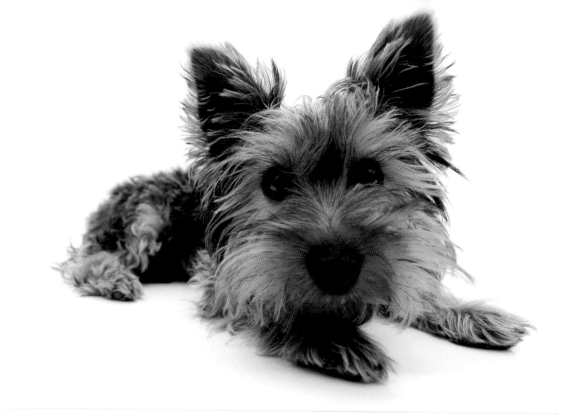

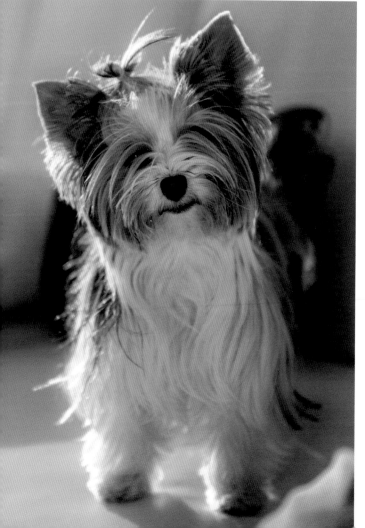

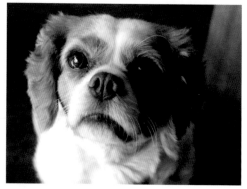

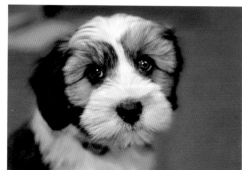

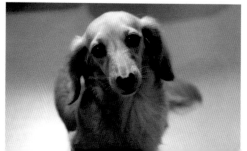

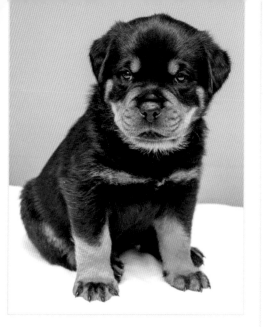
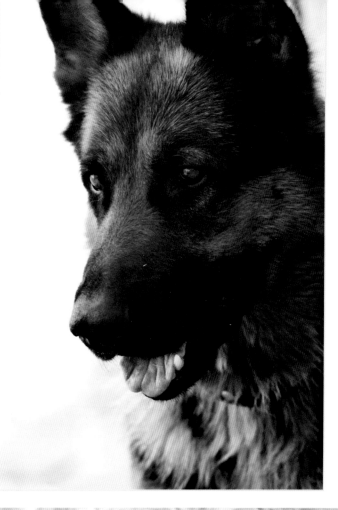
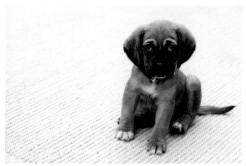
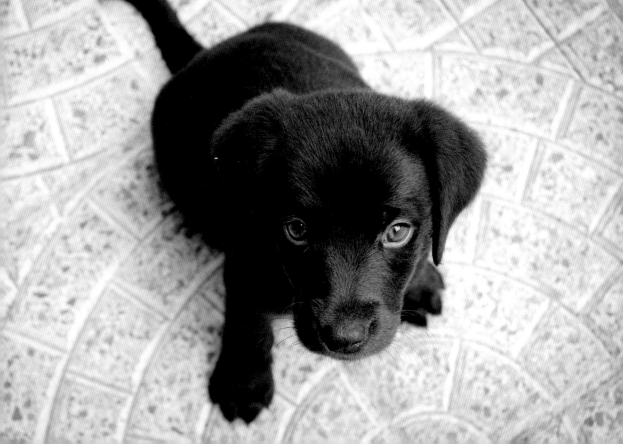

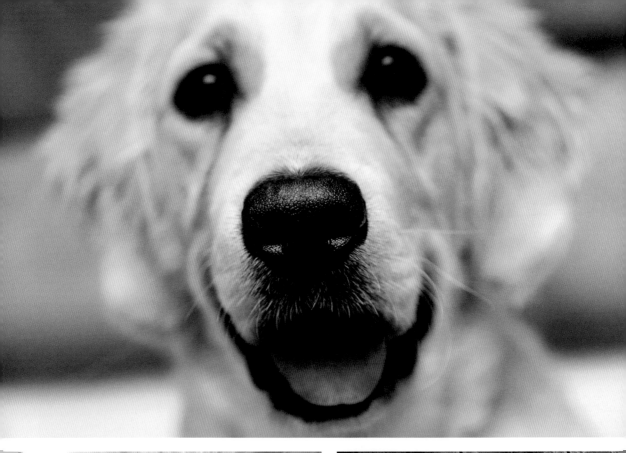

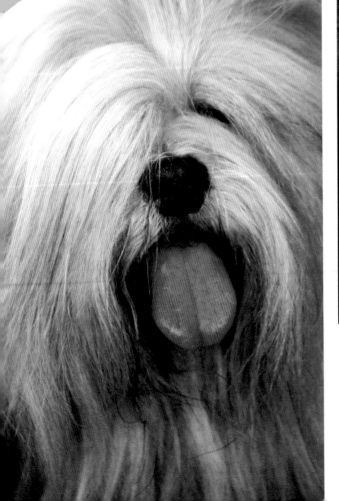

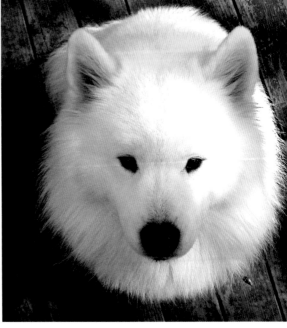

"The better I get to know men, the more I find myself loving dogs." –Charles de Gaulle

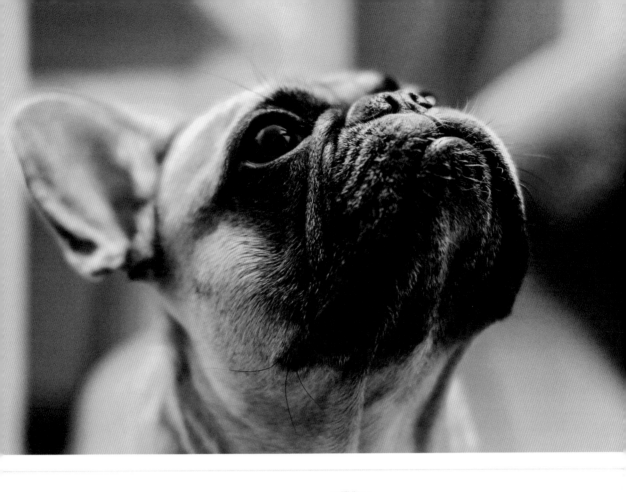
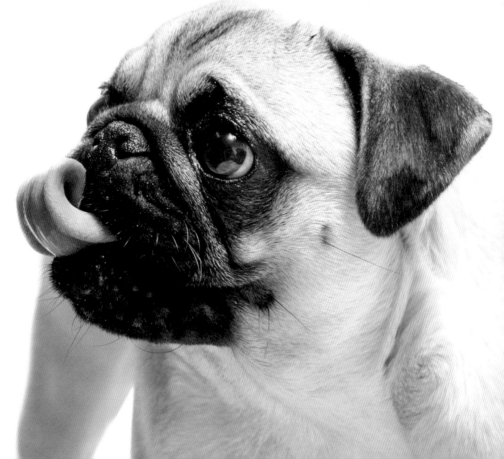

6. Action!

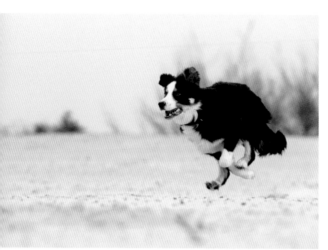

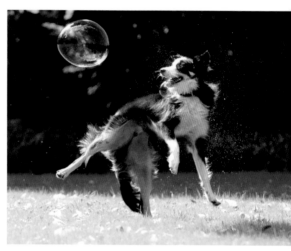

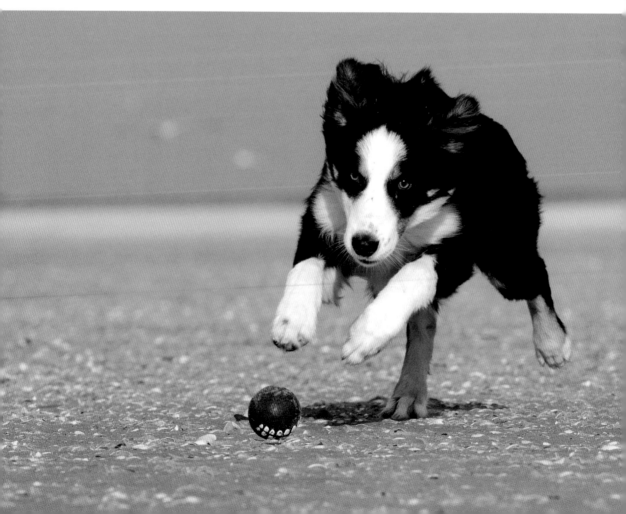

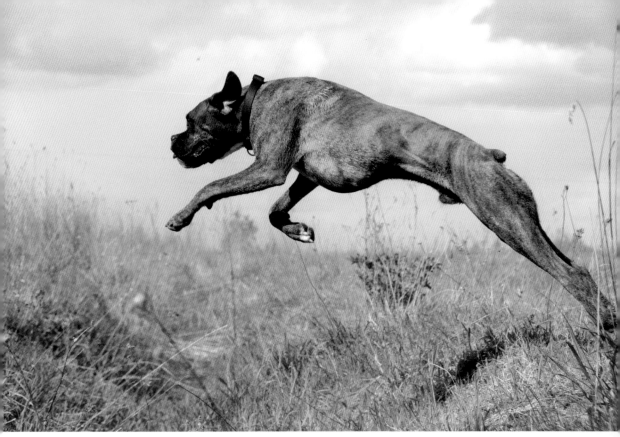

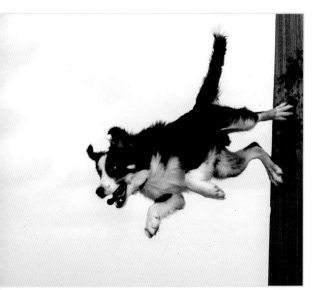

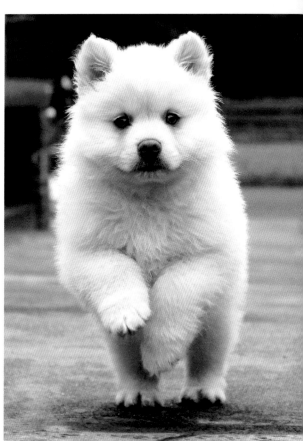

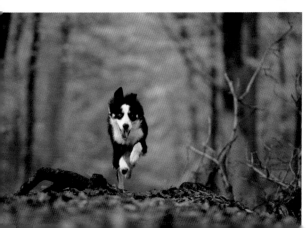

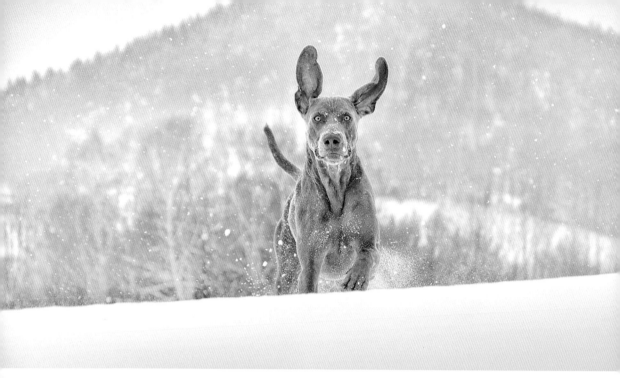

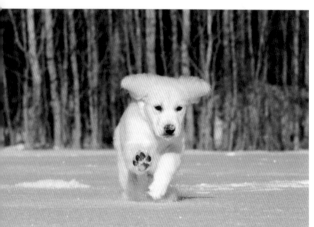

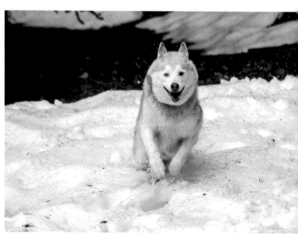

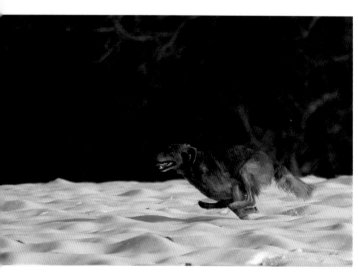

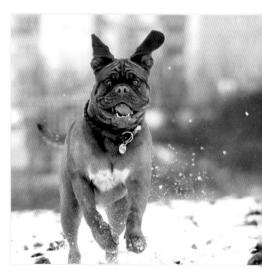

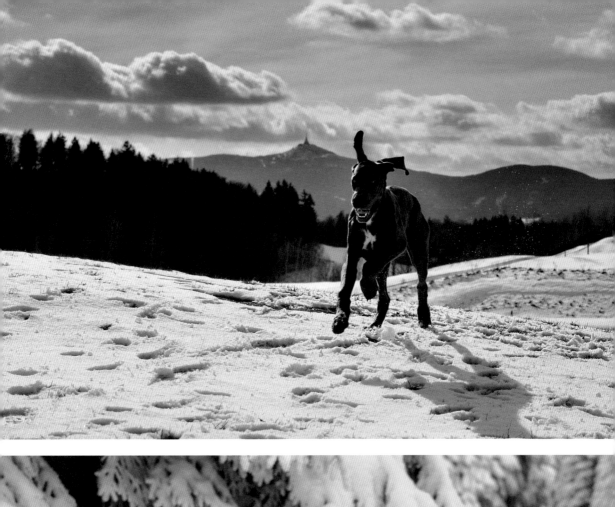
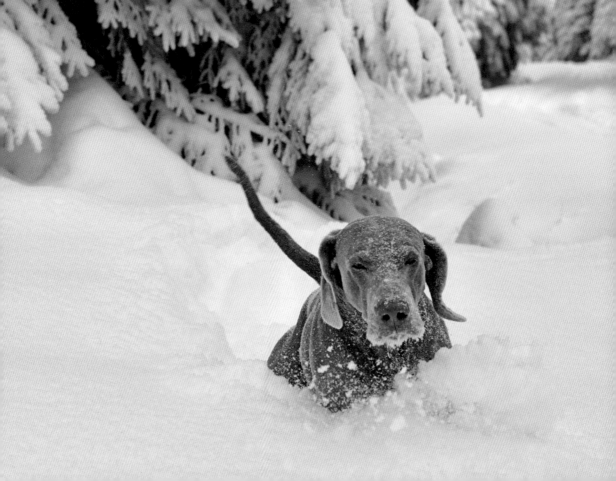

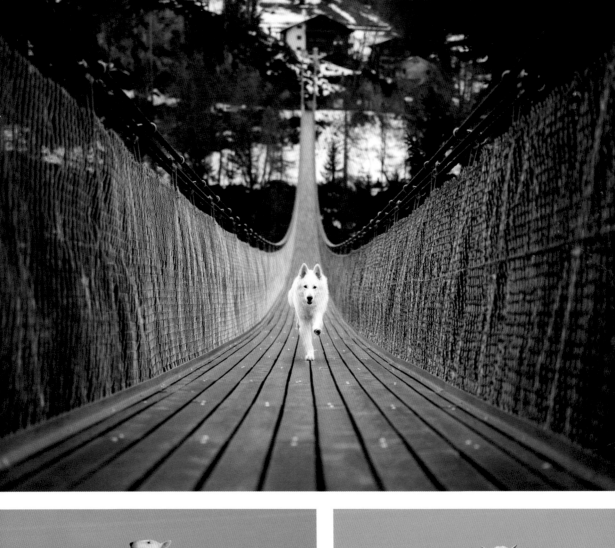

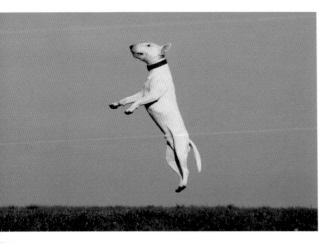

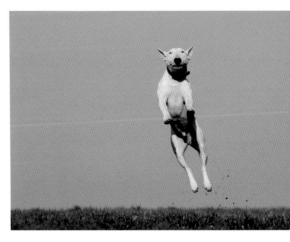

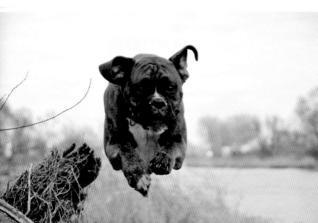

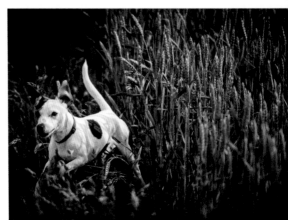

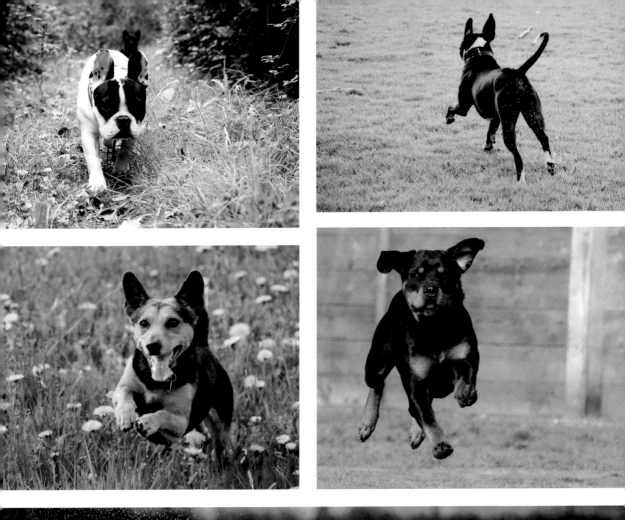
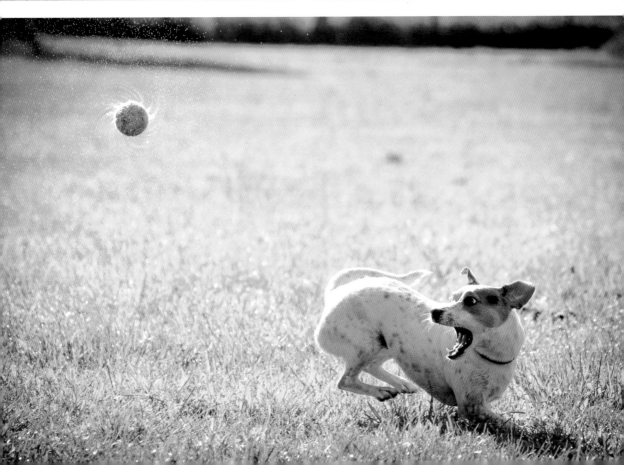

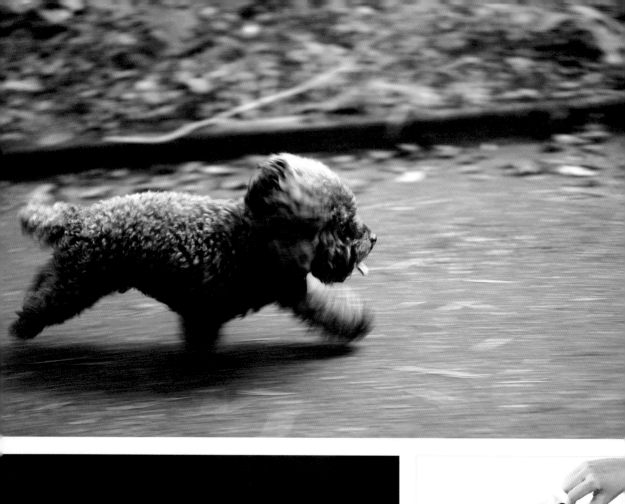

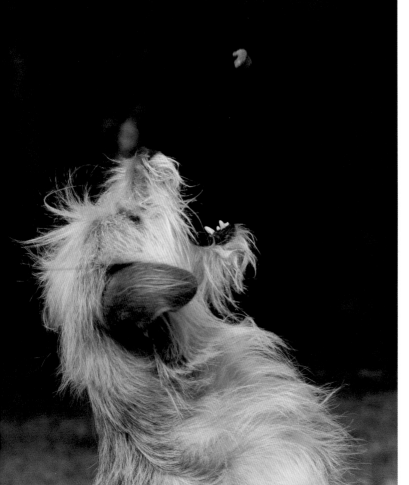

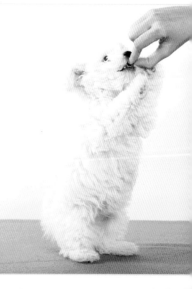

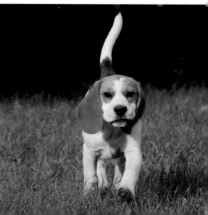

7. Time to Relax

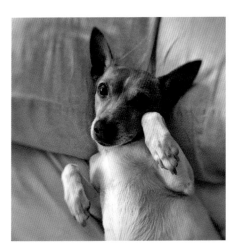

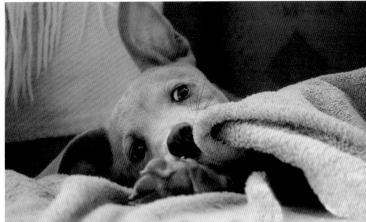

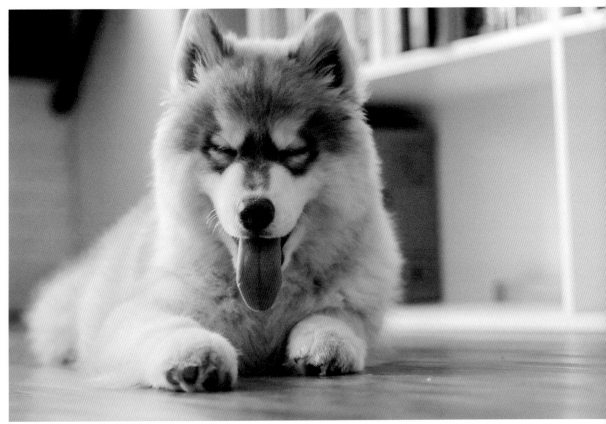

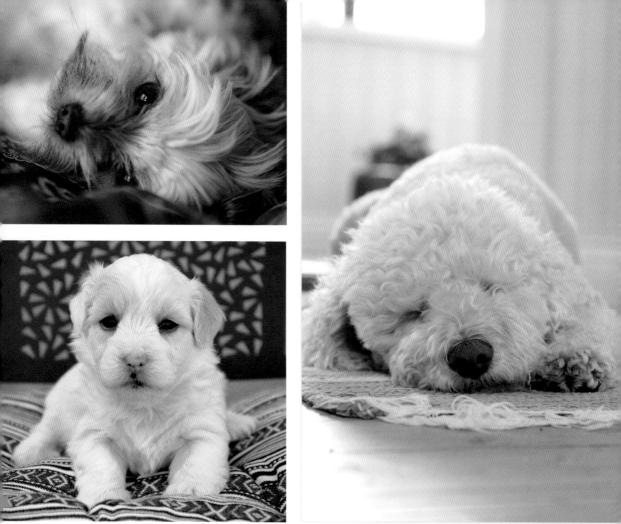
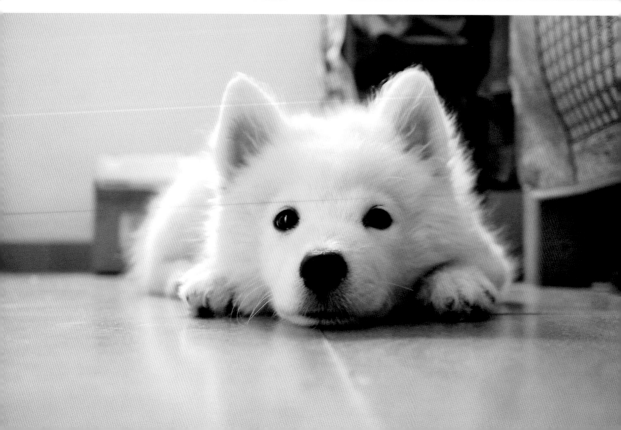

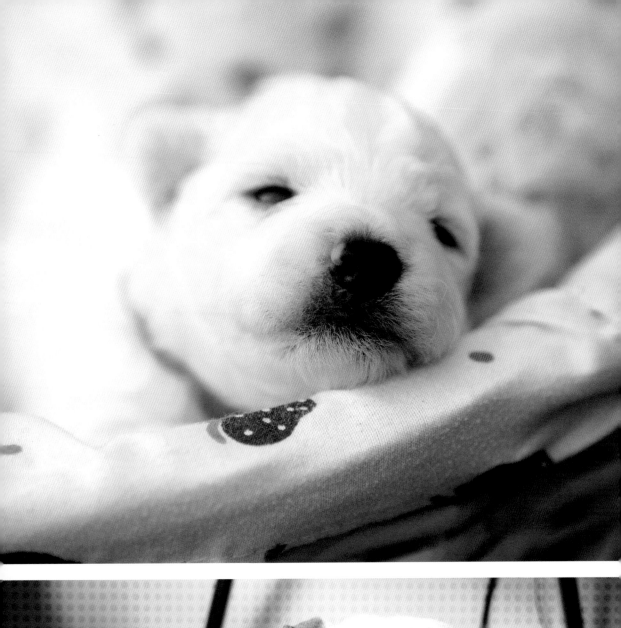
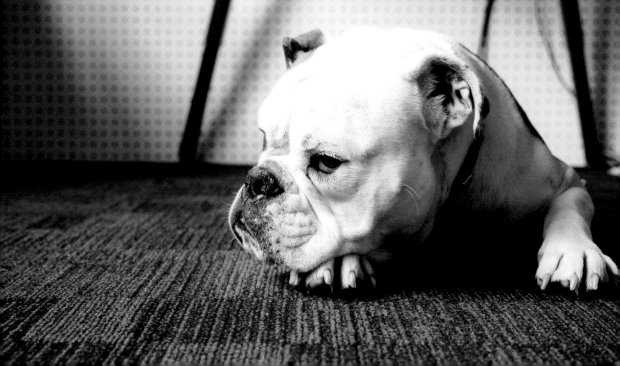

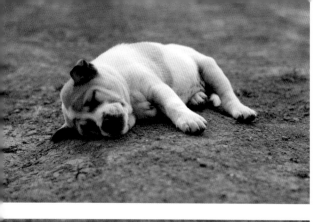
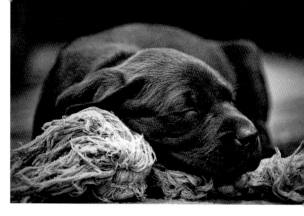
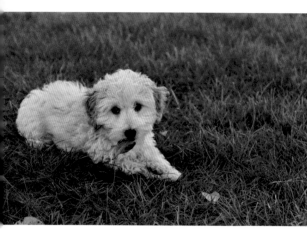
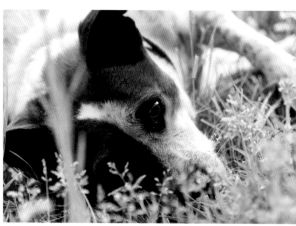
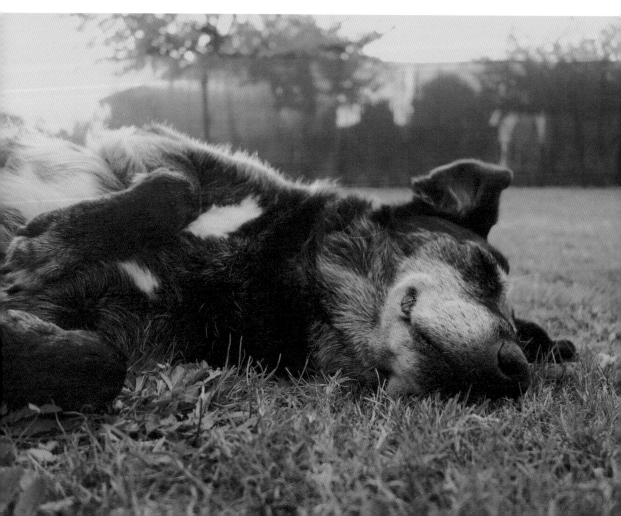

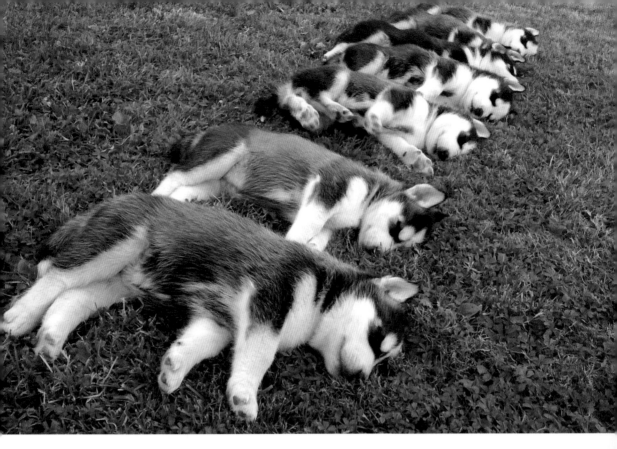

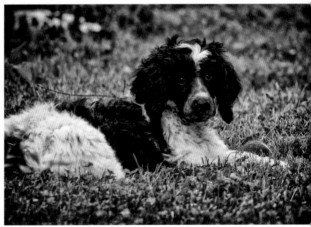

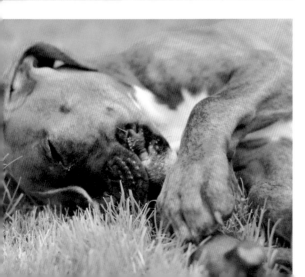

"Some of my best leading men have been dogs and horses."

—Elizabeth Taylor, actress

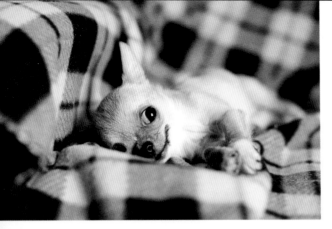

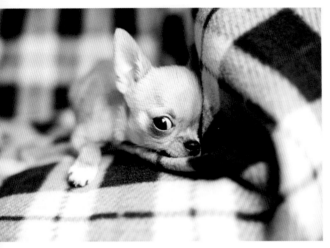

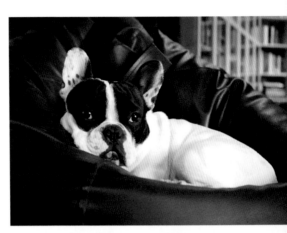

"Certain dogs I have known will go to heaven—and very, very few persons."

—James Thurber, author

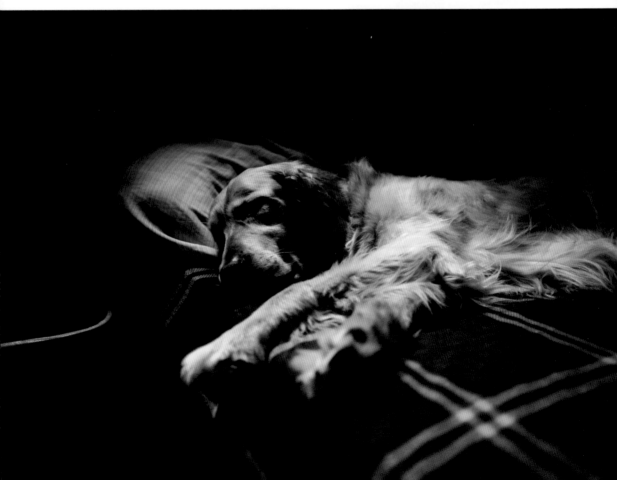

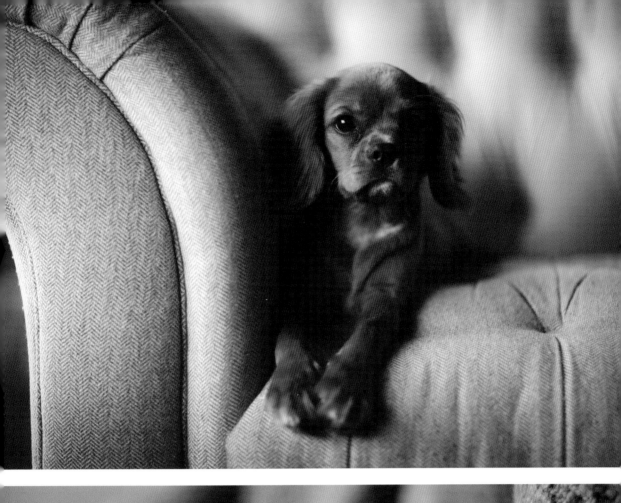
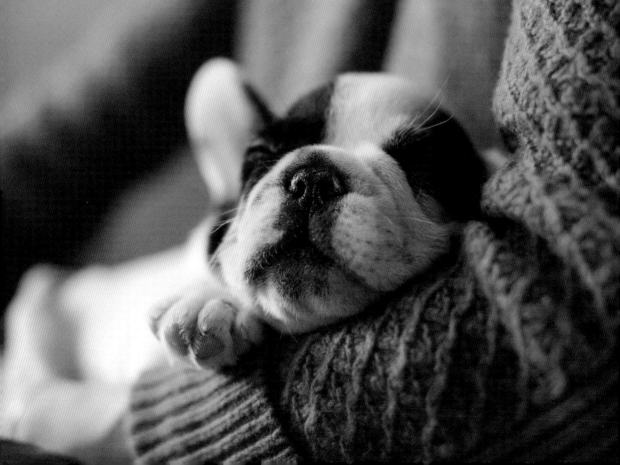

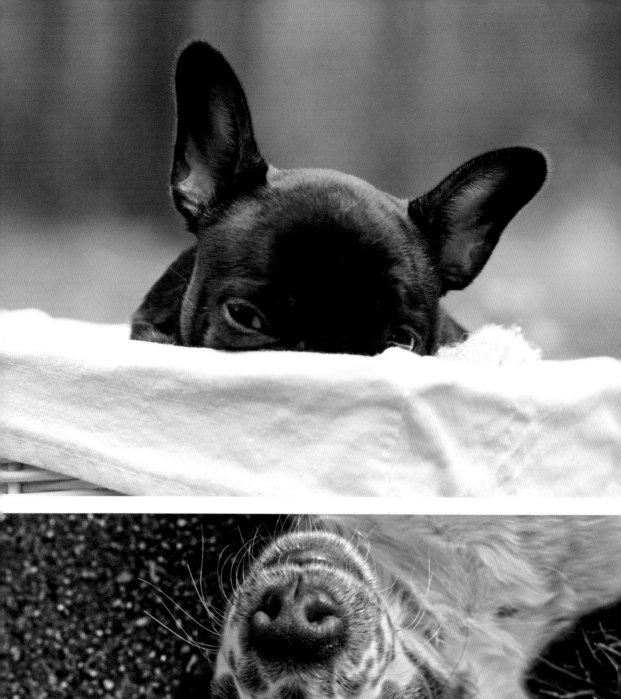
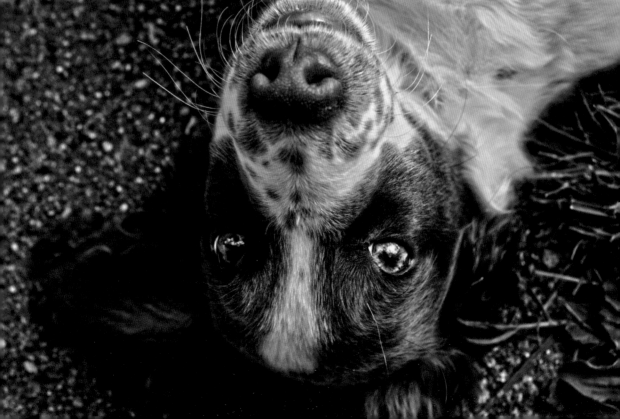

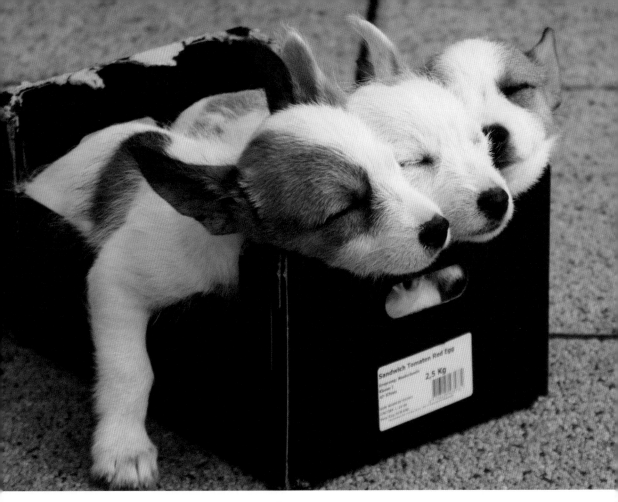

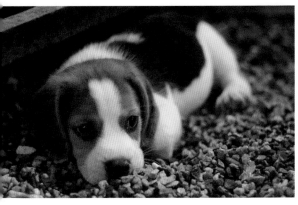

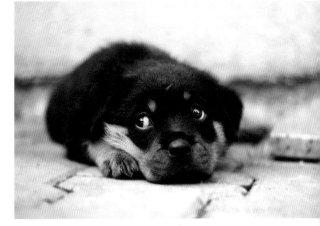

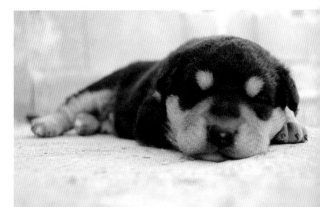

"A dog will teach you unconditional love. If you can have that in your life, things won't be too bad."

—Robert Wagner, actor

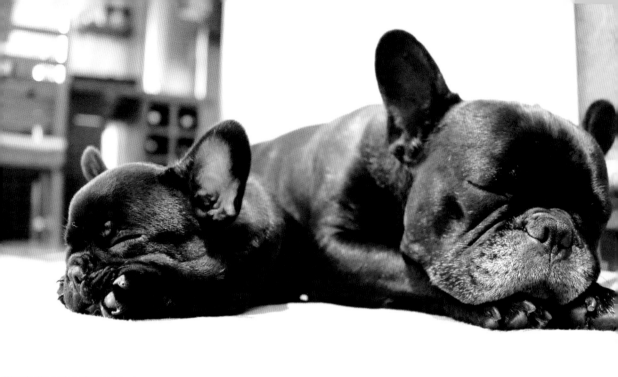
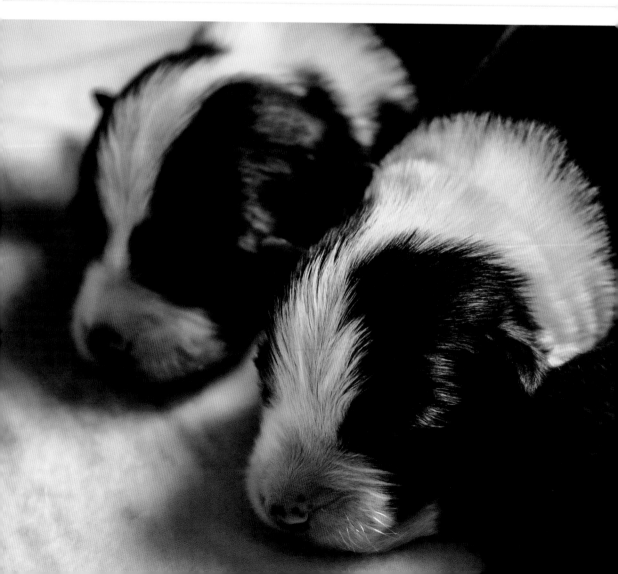

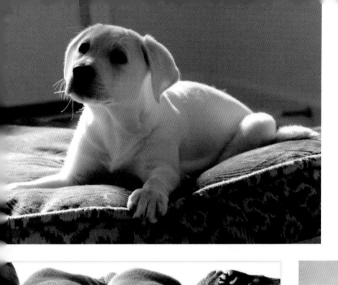
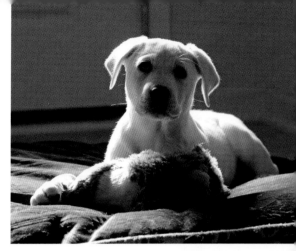
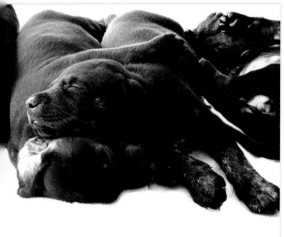
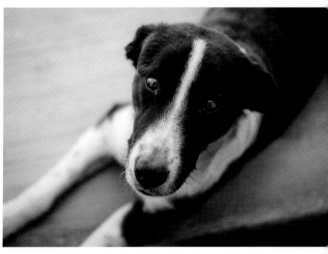
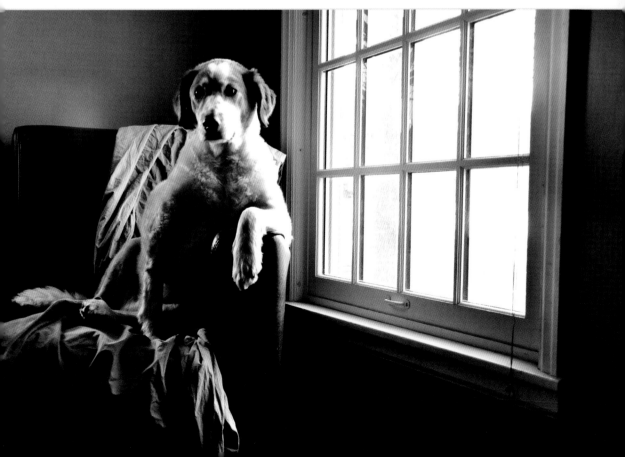

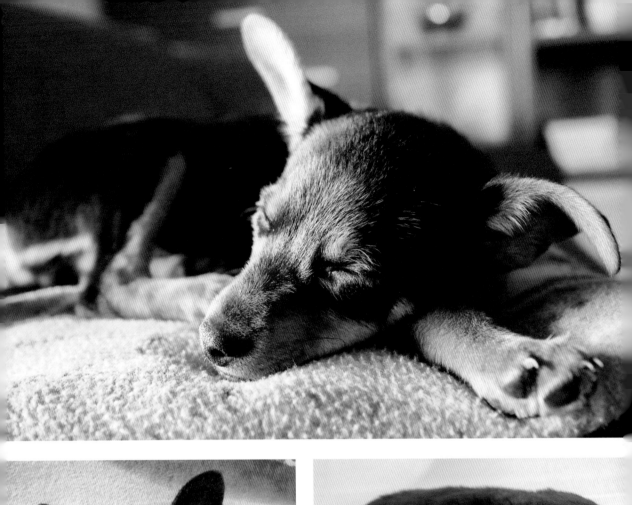
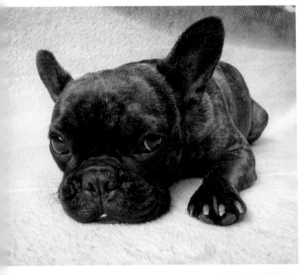
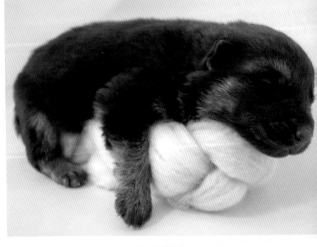
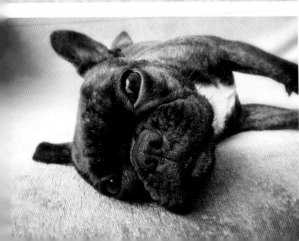
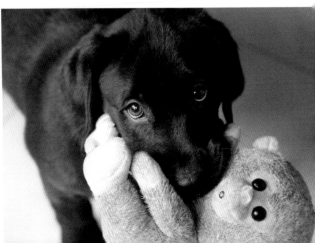

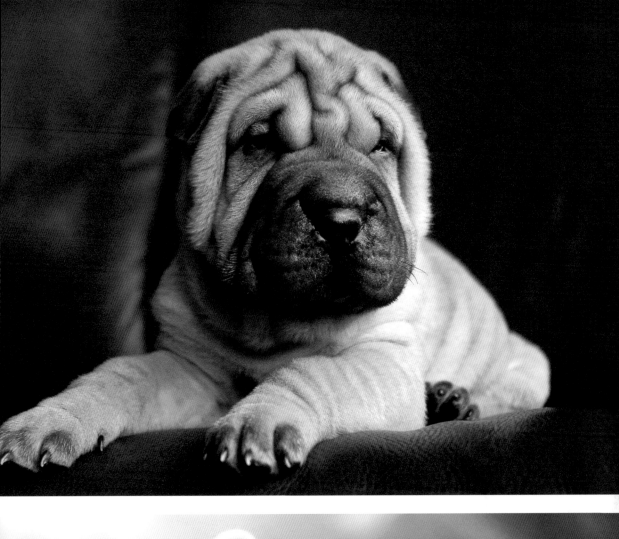
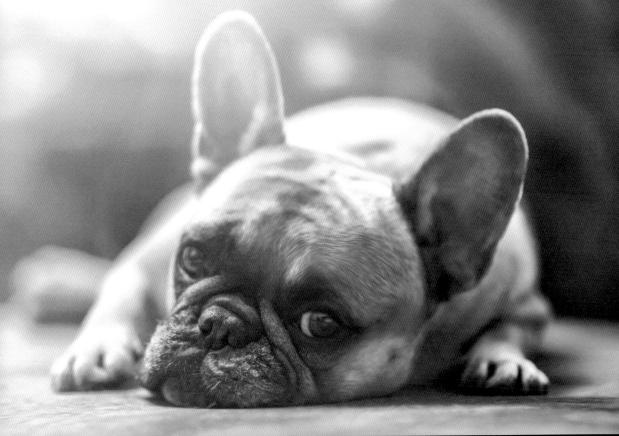

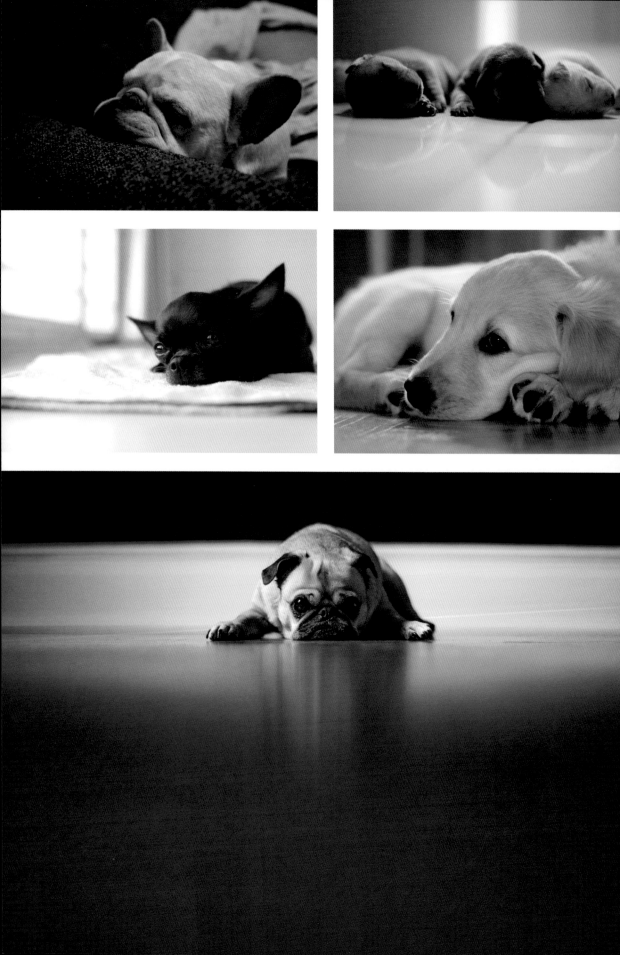

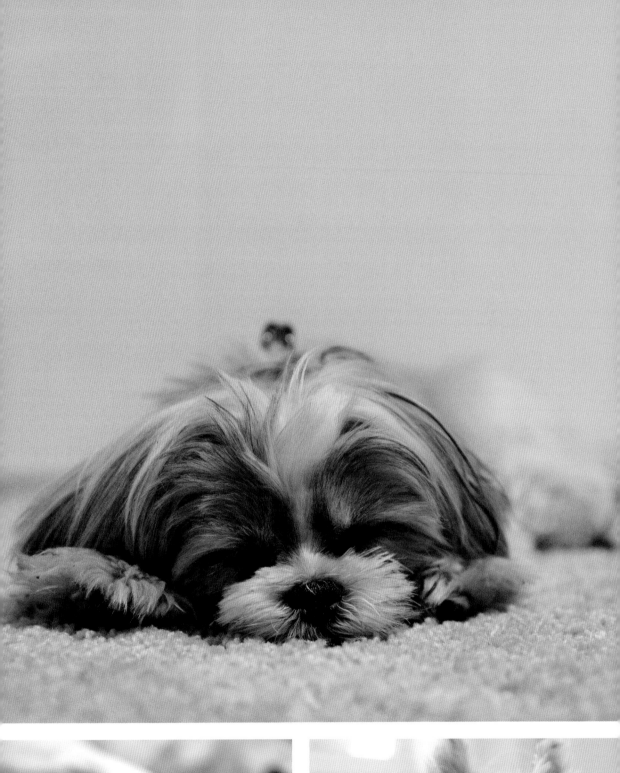

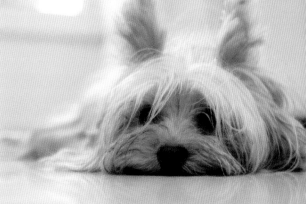

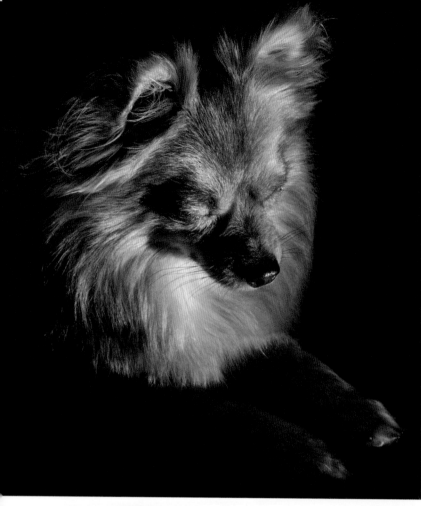

"If a dog will not come to you after having looked you in the face, you should go home and examine your conscience."

—Woodrow Wilson,
President of the United States

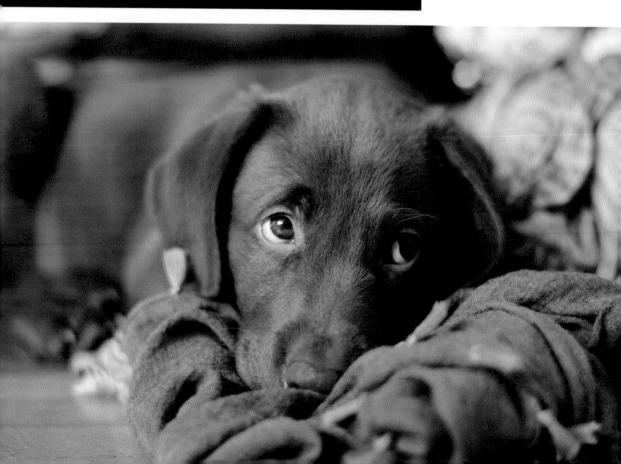

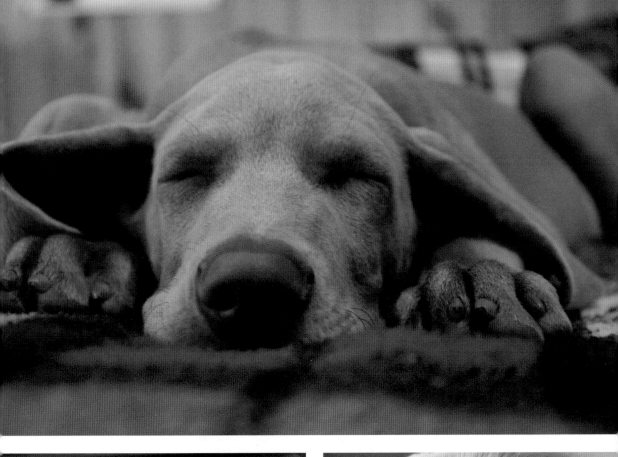

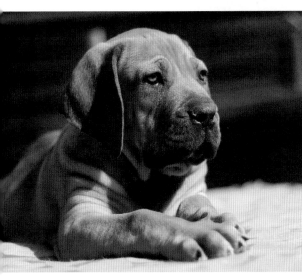

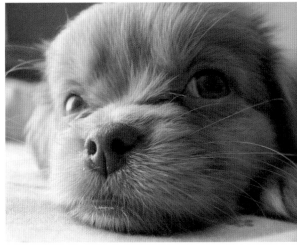

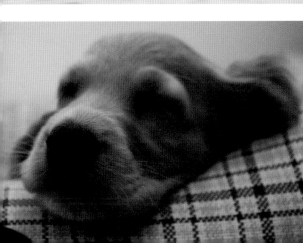

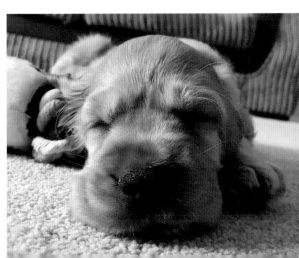

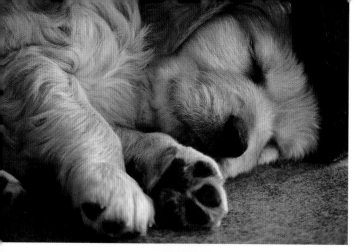

"The world would be a nicer place if everyone had the ability to love as unconditionally as a dog."

—M.K. Clinton, author

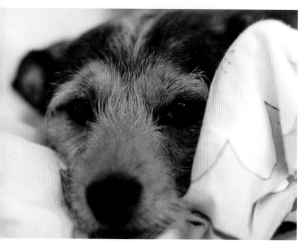

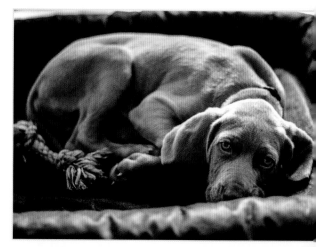

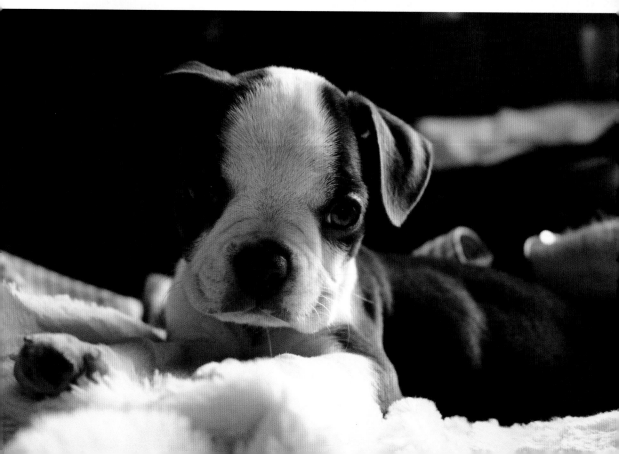

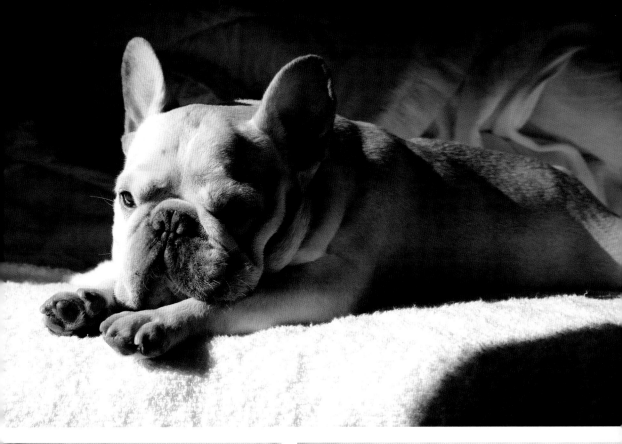

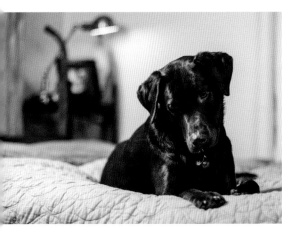

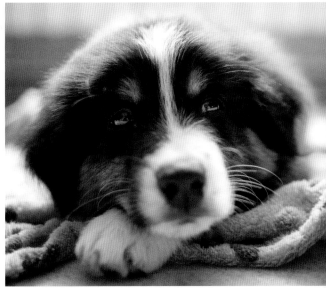

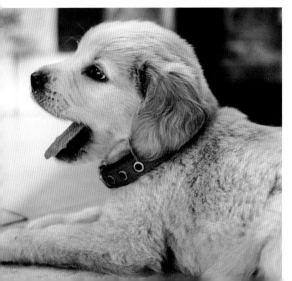

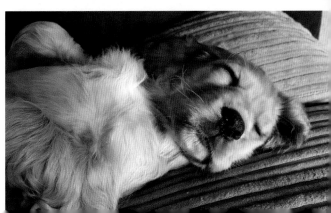

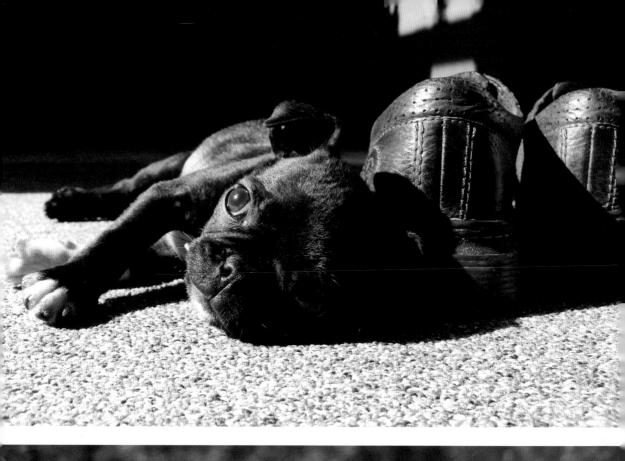
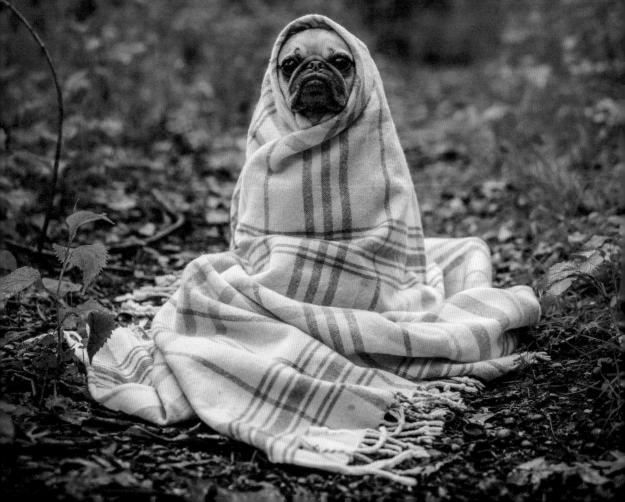

Conclusion

Hopefully, the sweet faces in these pages have brought a smile to your face! Now would be a great time to go hug your own pet—and, if you are able, consider donating to a rescue or animal care group in your area to ensure that all our furry friends have safe, happy lives.

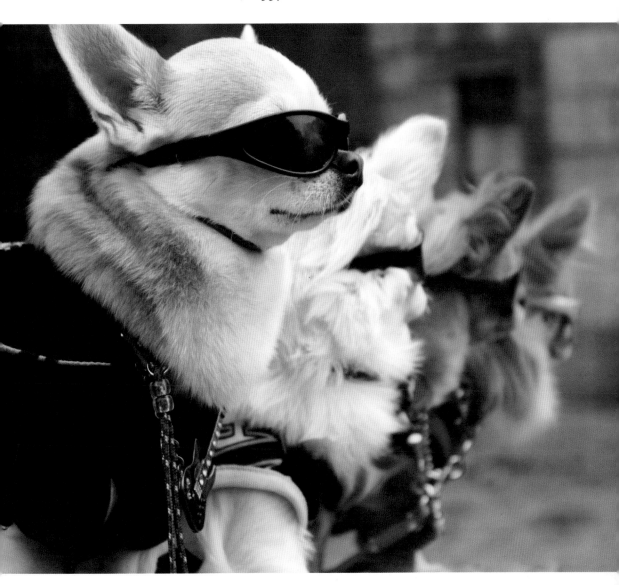

Rescue Dogs
PORTRAITS AND STORIES

Susannah Maynard shares heartwarming stories of pups who have found their forever homes. *$21.95 list, 7x10, 128p, 180 color images, index, order no. 2161.*

Storm Chaser
A VISUAL TOUR OF SEVERE WEATHER

Photographer David Mayhew takes you on a breathtaking, up-close tour of extreme weather events. *$24.95 list, 7x10, 128p, 180 color images, index, order no. 2160.*

Rock & Roll CONCERT AND BACKSTAGE
PHOTOGRAPHS FROM THE 1970S AND 1980S

Peter Singer shares his photos and stories from two decades behind the scenes at classic concerts. *$24.95 list, 7x10, 128p, 180 color images, index, order no. 2158.*

Hubble Images from Space

The Hubble Space Telescope launched in 1990 and has recorded some of the most detailed images of space ever captured. *$24.95 list, 7x10, 128p, 180 color images, index, order no. 2162.*

Big Cats in the Wild

Joe McDonald's book teaches you everything you want to know about the habits and habitats of the world's most powerful and majestic big cats. *$24.95 list, 7x10, 128p, 220 color images, index, order no. 2172.*

Cute Babies

Relax your mind and renew your sense of optimism by perusing this heartwarming collection of precious faces and tiny features. *$24.95 list, 7x10, 128p, 500 color images, index, order no. 2173.*

Art with an iPhone, 2nd ed.

Kat Sloma's elegant images reveal the iPhone as a sophisticated art-making tool. In this book, she walks you through her inventive approach. *$24.95 list, 7x10, 128p, 300 color images, index, order no. 2165.*

iPhone Photography for Everybody

Accomplished photojournalist Michael Fagans shows you how to create awesome photos with your iPhone. *$19.95 list, 7x10, 128p, 180 color images, index, order no. 2157.*

Pet and Horse Photography for Everybody

Nicole Begley teaches you to bring out the best in your favorite animals and capture outstanding photographs. *$24.95 list, 7x10 128p, 180 color images, index, order no. 2142.*

Rocky Mountain High Peaks

Explore the incredible beauty of America's great range with Brian Tedesco and a team of top nature photographers. *$24.95 list, 7x10, 128p, 180 color images, index, order no. 2154.*